THE SPIRIT OF
SCOTLAND

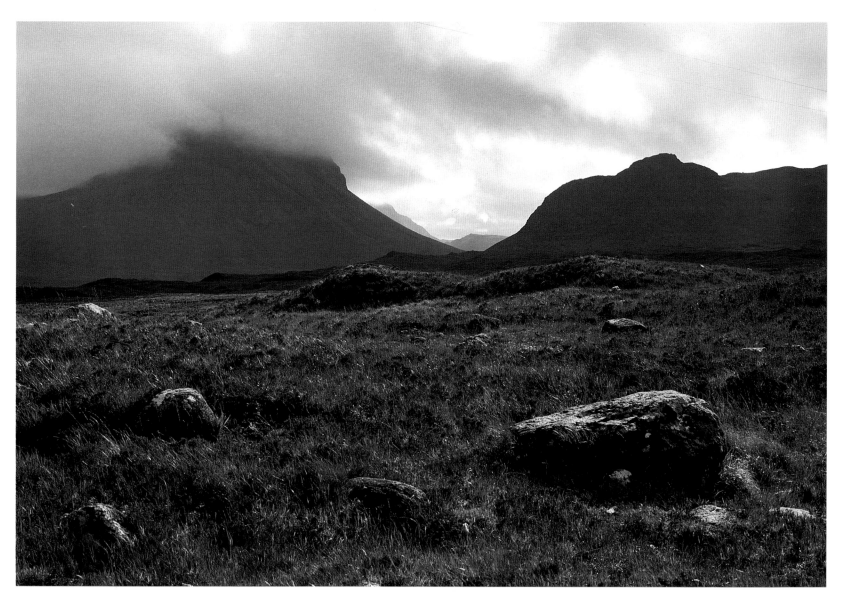

The Cuillin from the north of Minginish

THE SPIRIT OF SCOTLAND

SIMON McBRIDE

Foreword by Des Hannigan

Webb & Bower

DEDICATION
To my mother and father

ACKNOWLEDGEMENTS

I would like to thank all those nameless people who gave me help on my many journeys through Scotland; my appreciation to Peter Wrigley for his caring commitment; and my gratitude to Des Hannigan whose involvement in this book was all embracing and a personal pleasure to me. Finally, thank you to my wife, Sarah, for her continued support.

The publishers wish to thank Canongate Press for permission to quote an extract from Sgurr Nan Gillean from the poem The Cuillin *by Sorley Maclean.*

First published in Great Britain 1991 by
Webb & Bower (Publishers) Limited
5 Cathedral Close, Exeter, Devon EX1 1EZ

Distributed by the Penguin Group
Penguin Books Ltd, Registered Offices: Harmondsworth
Middlesex, England
Viking Penguin Inc, 375 Hudson Street, New York, NY 10014, USA
Penguin Books Australia Ltd, Ringwood, Victoria, Australia
Penguin Books Canada Ltd, 2801 John Street, Markham, Ontario, Canada L3R 1B4
Penguin Books (NZ) Ltd, 182-190 Wairau Road, Auckland 10, New Zealand

Designed by Peter Wrigley

Introduction and Illustrations Copyright © 1991 Simon McBride
Foreword Copyright © 1991 Des Hannigan

British Library Cataloguing in Publication Data
McBride, Simon
 The spirit of Scotland.
 1. Scotland. Landscape
 I. Title
719.09411

ISBN 0-86350-371-3

Library of Congress Catalog Card Number: 91–65262

Text set in Janson 55 (11 on 12pt)

Typeset in Great Britain by P&M Typesetting Ltd, Exeter, Devon
Colour and mono reproduction by Mandarin Offset, Hong Kong

Printed and bound in Italy by Amilcare Pizzi SpA

CONTENTS

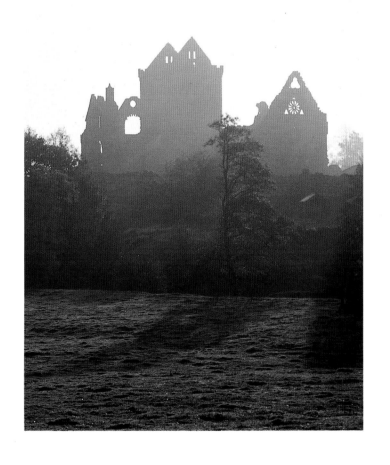

*Sweetheart Abbey, New Abbey, Dumfriesshire, a
thirteenth-century Cistercian monastery*

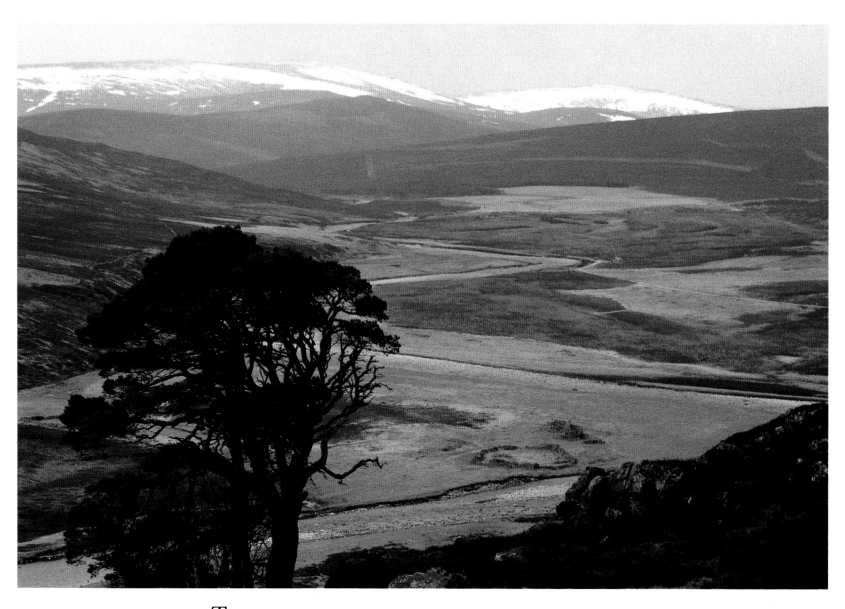

The winding River Dee and sentinel Caledonian pine tree, Forest of Mar

FOREWORD

No one looks at Scotland without a second glance. After that the eye is dazzled by images that are not only scenes but are layered one upon the other as densely complex and compelling as the history of the nation itself.

Such images demand a special kind of photographer to capture them, and through Simon McBride the 'Spirit of Scotland' has found vital expression.

The subject is awesome; the responsibility also. For Scotland is a country of no false pride and will not be flattered. Its landscape is bred into the bones of its people, its spirit has enlightened the world. This is a country which starts at the bare swooping Borderlands where Northumbria nudges the Cheviot Hills into the north and lies easy with the Solway Firth. Vast landscapes spill northwards like a green running sea through which generations of invaders ploughed their way, fearful of the great waste beyond.

For many of them, the welcome surprise of the fertile belt of Central Scotland was short-lived; an oasis to be exploited certainly, but overshadowed by the great wall of the north that strikes from Stonehaven to the Clyde like a sword blow. It drew the Romans on to fearful slaughter and defied the English suzerains until Scotland fragmented under the strain of dynastic conflict and modernization. It is a story written across the pages of this book. Its theme is sovereign landscape; the medium is great photography.

The narrative thread of *The Spirit of Scotland* weaves its way from the broom-dark Galloway Hills through the shepherd's country of Ettrick and Teviotdale across Eildon's snowy heights to the wide shores of the North Sea. From the banks of the Solway, Simon McBride takes his camera through pastoral Ayrshire to Burns' country and across the waist of Scotland to Edinburgh like the poet's own journey.

There is a classic McBride photograph of Princes Street after rain, half-framed by trees and like a distant river. Always those fluid images of wild landscape and stream; they link the heart of the great city with the slow glide of Hermitage Water in the Border heartland, with far Loch Duich's mirrored calm and Skye's gleaming moss. Images of Edinburgh merge naturally with pictures of the handsome Mid Causeway of Culross and of St Andrews across a cold, fretting sea.

Beyond the cities to the north and north-west lie the rough bounds of the Highlands and Islands whose great mountains and lochs have been sculpted and moulded by the cutting edge of ice and water and the hammer blows of the sea.

Yet Scotland's cities reflect such landscape through the style of their architecture. Edinburgh's European face has good Scottish bone structure; its buildings match the powerful fall of buttress and ridge in the mountains of Argyll and Torridon. Glasgow, the powerhouse of Scottish industry and commerce, has a sturdier weather front like the great headlands and peninsulas of the North or the stacks of Duncansby Head on their silver sea. This is the complex and wonderful Scottish diversity that Simon McBride has captured with his artist's eye.

Reach into these images of Scotland and you move through the frame into the soft, sweet rain of Loch Leven or the dazzling bronze light of a Cairngorm sunset. There are no hard edges, even in pictures of the great hills and wild skies of the unforgiving north, the frozen wastes of mountains in winter, the sweet melancholy of Glenshee and Glencoe and the sparse low hills and matching lochs of Strathnaver.

It is a country where the weather alone will cure you of whimsy and where, if you stand still for too long in winter, your bones may fuse to the iron-hard ground. Even in high summer the mountains and coast can lie shrouded in thrawn mist for days, while great winds stream in from the west unloading the Atlantic. Stand anywhere in Scotland and you can see the weather coming a mile away.

All this demands a tough operator behind the lens. Simon McBride measures up. He can match Scotland eye to eye, unblinking before a country that will not be meddled with.

This is not guide-book Scotland. Nor is it a mere exercise in view-finding. It is Simon McBride finding character rather than cliché and working hard to do so.

Simon will spend hours living with one piece of landscape catching the changing light and shade, the sudden shift of the wind and the rhythm of the weather. I have watched him

perched on the break-neck slope of a sea-cliff in a gale of wind awaiting the right moment to pin down the image of a tearing sea, while I cowered in the lee of a rock.

He seemed hardly to notice the weather banging about his head; intent, determined, shifting only occasionally for a fresh angle, but never ceasing to watch. At other times, he stands with camera on tripod, at the still heart of a lonely mountainside fitting everything into the frame as if reordering the lie of the land itself. You swear there can't be a picture in it. But there always is.

It is a style developed by Simon McBride through long and varied experience. He spent years working solely in black and white. That was the accepted medium for both news photography and art work throughout the Sixties when Simon worked in photo-journalism and hard news. It taught him about line and form, space, movement and emphasis. *And* reality. He covered front-line conflicts in Rhodesia and Mozambique and the Middle East – a far cry from the still heart of landscape.

But hard news disciplines the eye and intellect with its movement, its ephemeral image, its violence even. It touches landscape photography thereafter. For a photographer like Simon McBride all that experience blended with artistry has matured to an intense vision of landscape that has produced his long list of splendid books and has brought such a singular haunting quality to this *Spirit of Scotland*.

DES HANNIGAN

INTRODUCTION

It is so easy to be overwhelmed by the grandeur of Scotland's Highland scenery. To most outsiders, Scotland conjures up images of endless snow-covered mountains dissected by salmon-filled, crystal clear rivers which both feed and are fed by tree-lined lochs – some more infamous than others!

While many of these natural phenomena do exist in wonderful abundance, they are just part of a large and varied country where the landscape, in all its different forms, has no rival anywhere in Europe. Photographing such a country poses a major dilemma for the landscape photographer. People half expect the cliché, yet it is the responsibility of the photographer to show more than the guide-book image. There has to be a compromise between the representative interpretation of the landscape and the unfolding of the unknown and often more thought-provoking image.

I have heard it said many times of a particular photograph, 'But it doesn't look like such and such place, it could be anywhere'. But surely part of the thrill of discovering a new landscape is to find that things do exist out of context; that a small, pretty oak wood can also be found in the Scottish Highlands, and not just in the Shires of England. Breath-taking scenery can become as monotonous as rows of terraced houses, and one should look for detail to help focus the mind. I have tried to capture both the vista and the detail in this book, without, hopefully, losing the feel of the land.

Scotland offers so much variety in its landscape that it would be wrong to linger too long on just one favoured area. However, I have not necessarily photographed every feature or part of the country. This is *not* an all-inclusive guide book, and there are certain regions conspicuous by their absence. It was not my aim to create yet another book showing stunning views of the Cairngorms covered in snow taken from locations that only the fittest and dedicated few can reach. I am not trying to impress in the grand sense, but more to reveal the subtleties and delights of a land that most people can appreciate in person, even if they were to look beyond the obvious.

Scotland has the seasons in double doses! I have never tired of photographing it at any time of the year – even in mid-February, usually the dead-light time of the season's cycle. The combination of dramatic topography and awesome Atlantic weather patterns produces an extraordinary quality of light which changes by the minute. I once stood on the top of Ben Venue in The Trossachs concentrating on the view across to Ben Lomond with the sun kissing the snow-covered peaks, when suddenly a snow-flake landed on the back of my neck and I turned to face a snarling storm racing over the Southern Highlands. Within minutes (after taking several very hurried shots) I was engulfed by a raging snow-storm. It was with relief and wonder that, some five hours later, having been helped down the mountain by experienced climbers, I looked back up to the Ben once again bathed in sunlight! A day later, I was walking the ancient cobbled streets of St Andrews in the dawn mists confronted with an entirely different set of problems. It is this uncompromising, volatile character that lures me back to Scotland over and over again and to photograph its landscape is an endlessly exhilarating and enjoyable experience.

I hope these pictures will impart that sense of joy and bring you a little closer to this magical country.

SIMON MCBRIDE

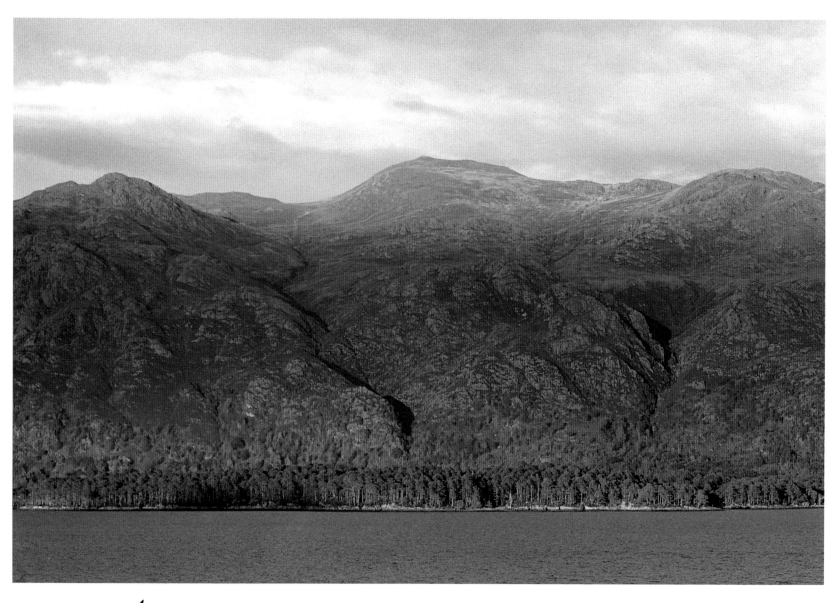

An empty quarter. The remote and lovely Kingairloch, north-east Morvern, seen across Loch Linnhe

THE SPIRIT OF
SCOTLAND

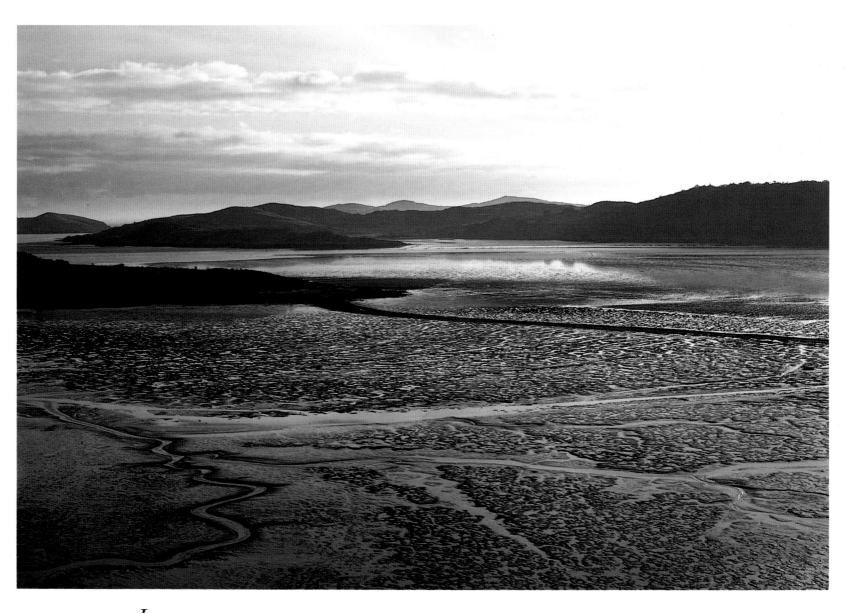

*L*and *and sea conjoin at Rough Firth near Kircudbright where the River Urr drains to the Solway*

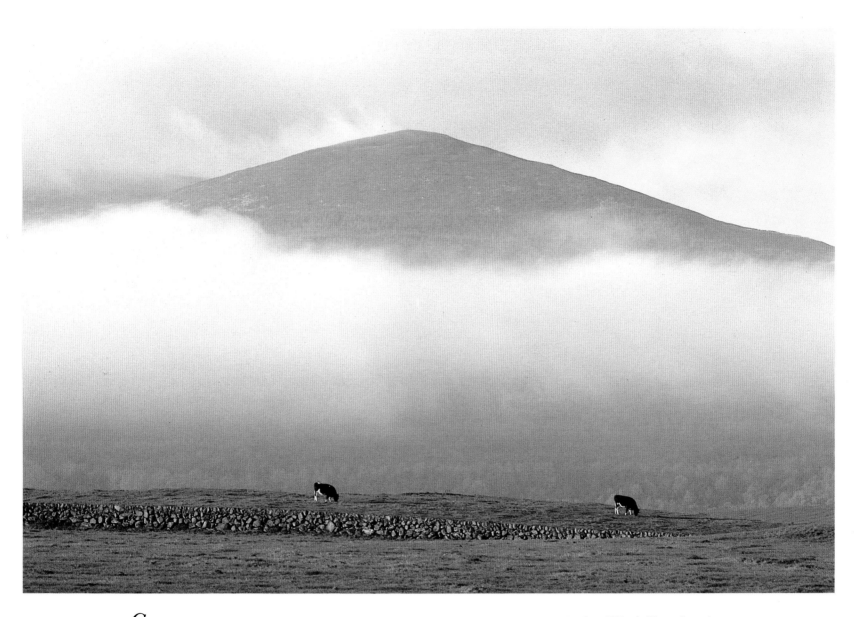

Criffel looming out of the early morning mist above Loch Kindar and the Cushat Wood, Dumfriesshire

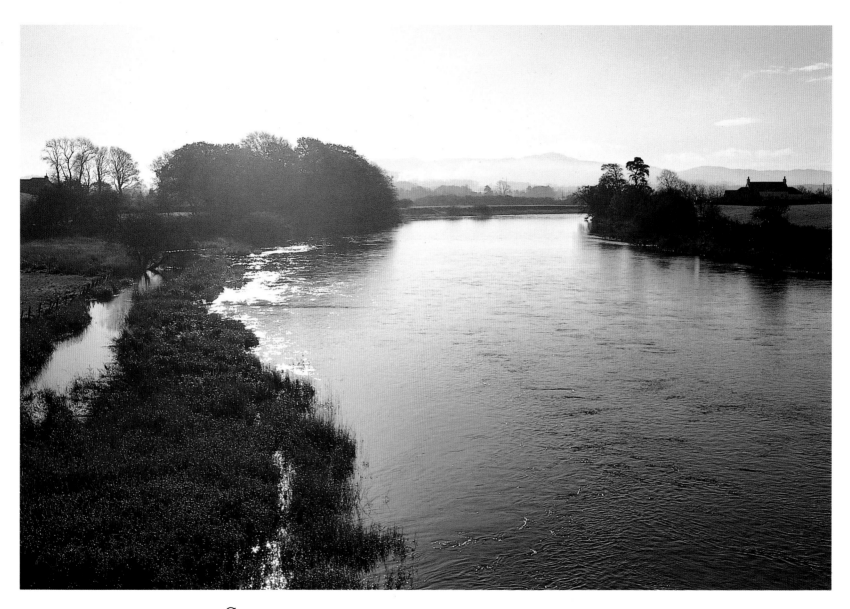

Sweet waters: the River Dee, near Castle Douglas, Kirkcudbrightshire

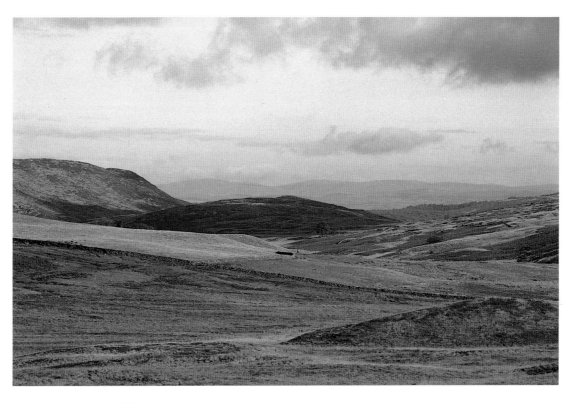

Broom-dark Gallowa': Airie Hill, Cairn Edward Forest
near Laurieston

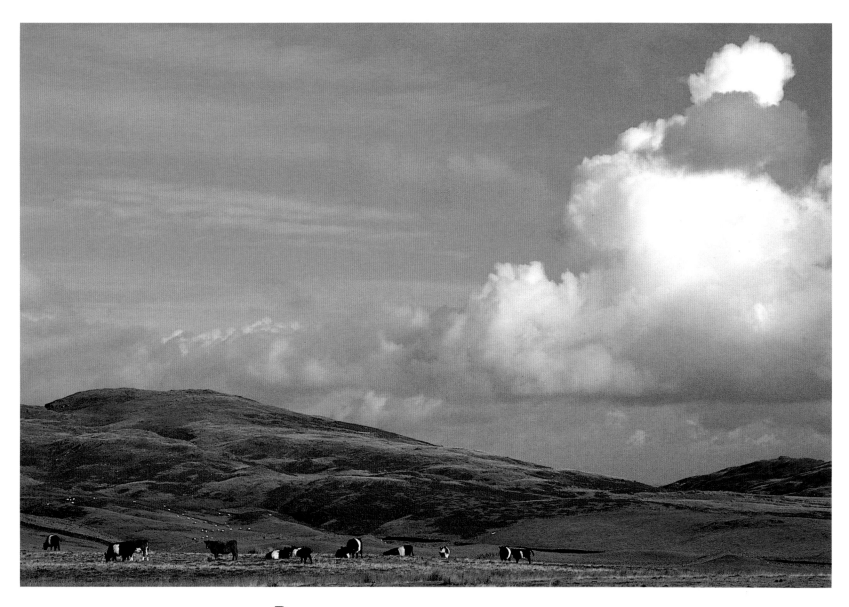

Belted Galloway cattle at home in the Galloway Hills

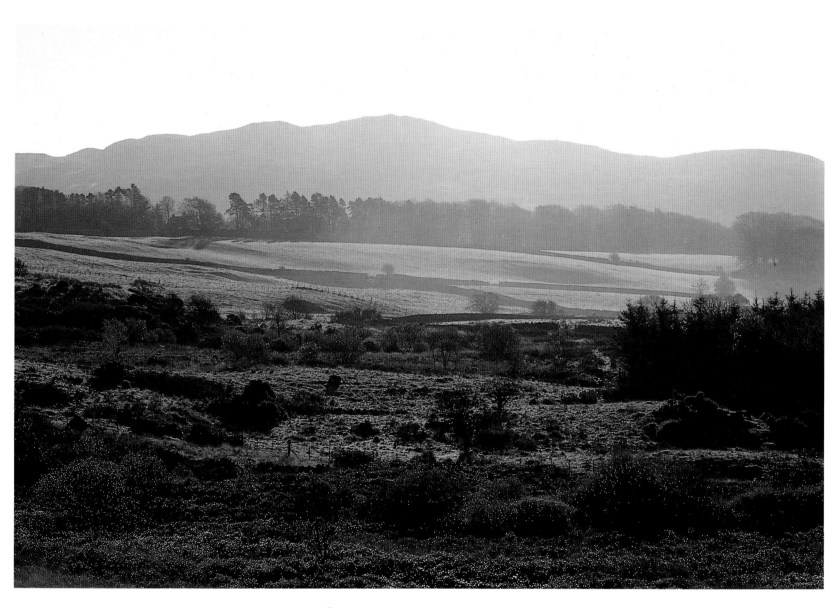

Autumn morning in mid-Galloway

Scottish pastoral: cattle grazing in a Dumfriesshire meadow

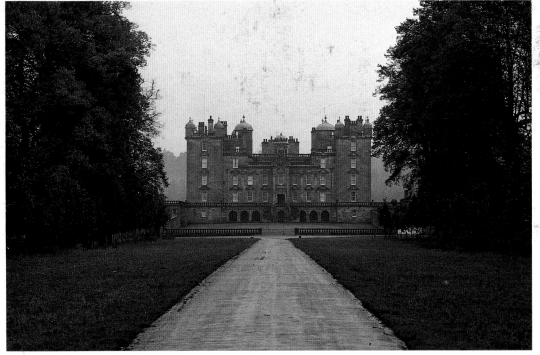

Drumlanrig Castle, Dumfriesshire, a late seventeenth-century building in the Scottish Renaissance style with richly ornamented facade but with good Scots turrets

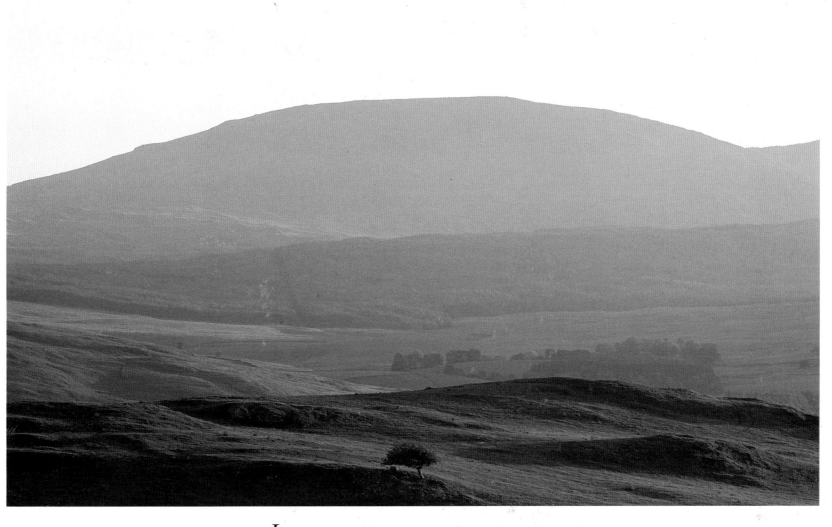

Like a green running sea – The land of Galloway

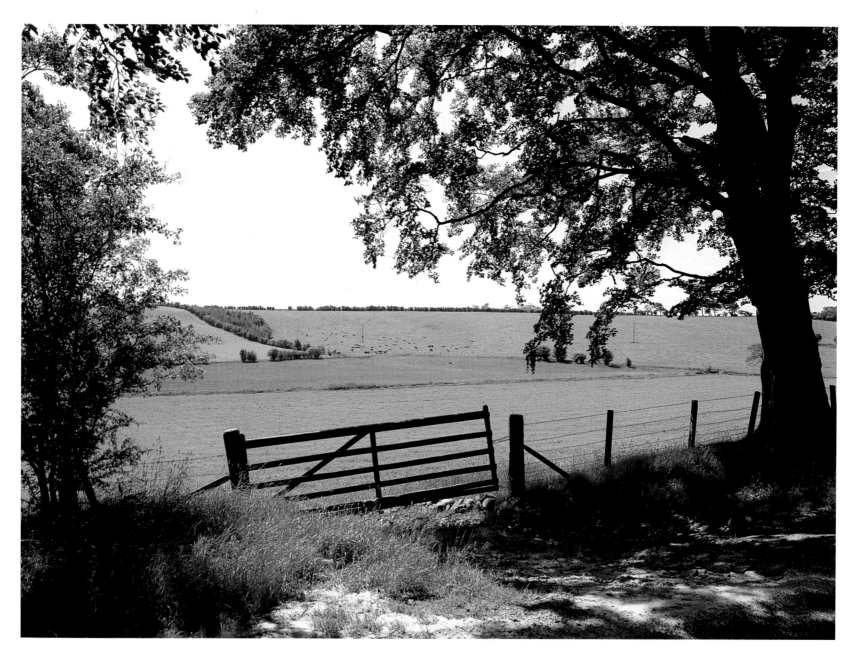

Ayrshire farmland: the green heart of Scotland

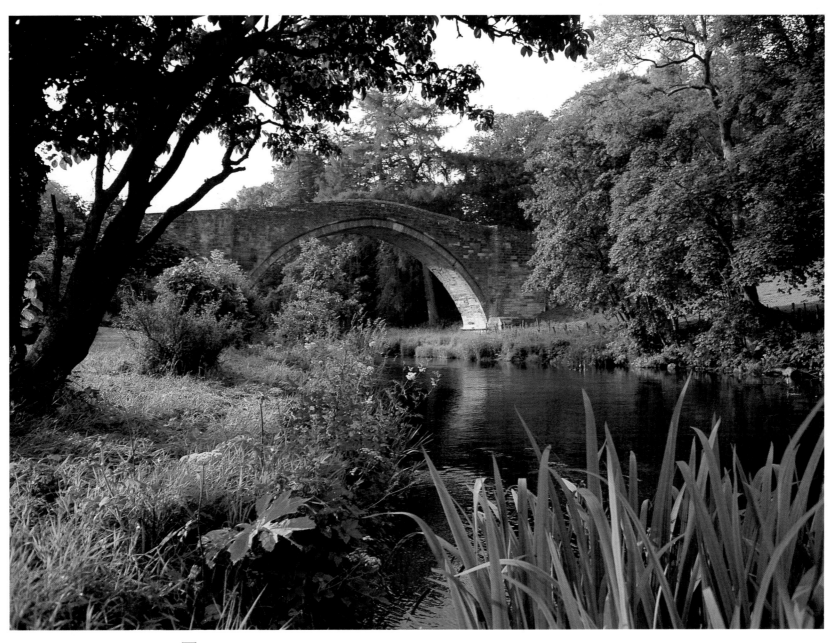

Tam o' Shanter Bridge over the River Doon where Tam, on his grey mare Meg,
finally escaped pursuit by witches in Burns' glorious poem

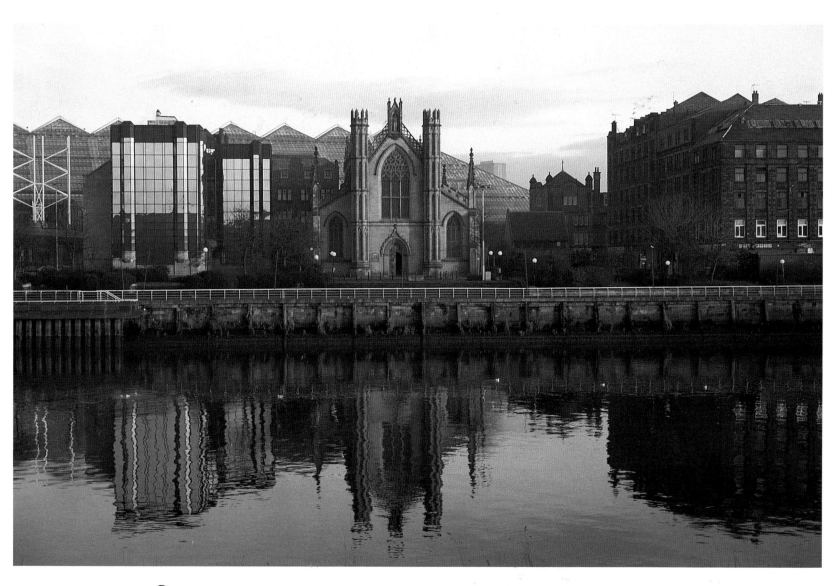

Glasgow's St Andrew's cathedral: nineteenth-century Gothic revival flanked by modernism, viewed across the Clyde

Left

*Glasgow – a unique mixture of Georgian elegance and
McKintosh design*

Above

Glasgow – Central Station

23

The River Clyde near Helensburgh

The green and 'bonny banks' of Loch Lomond

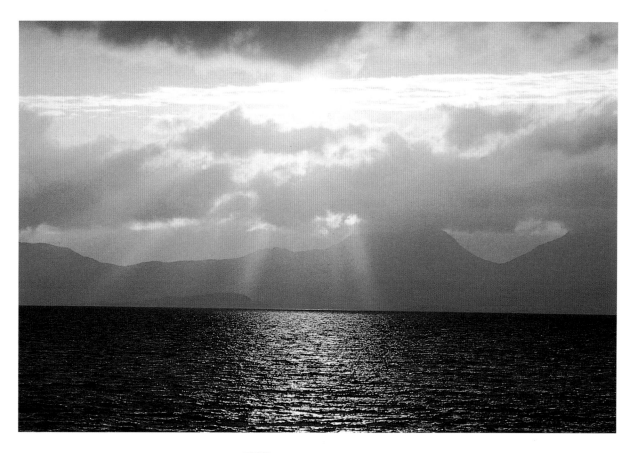

Winter sunset over Jura

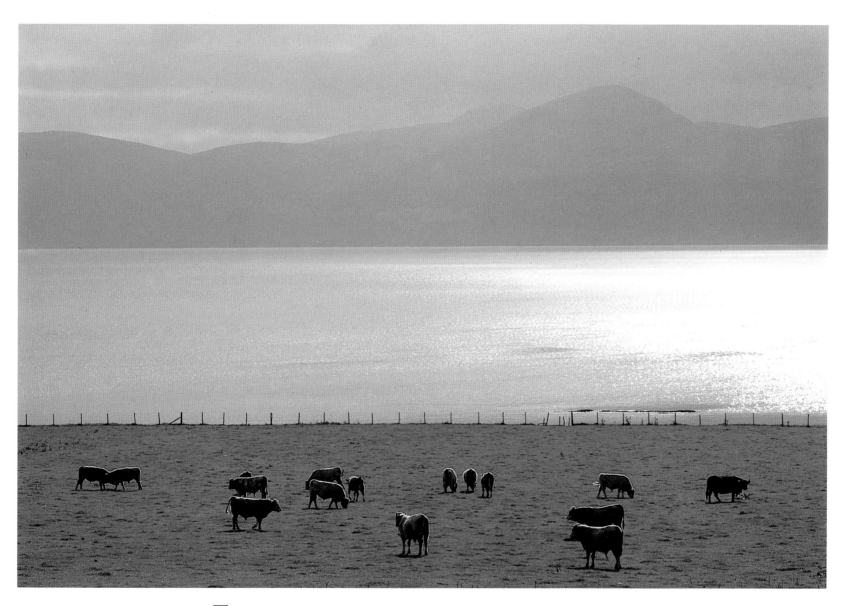

The flowing hills of Arran viewed across Kilbrannan Sound from Kintyre

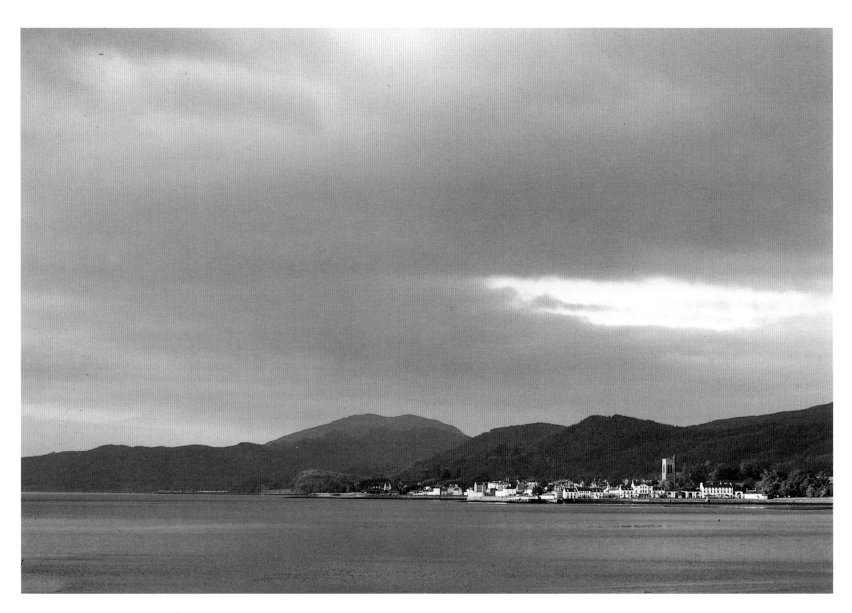

Campbell's kingdom. Inverary on Loch Fyne, the 'capital' of Argyll and of Clan Campbell

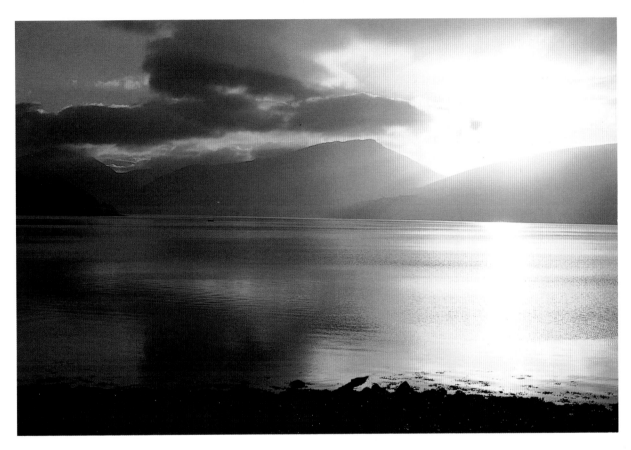

Loch Fyne, Argyll.

'The white dawn melted in the sky.'

Duncan Ban Macintyre

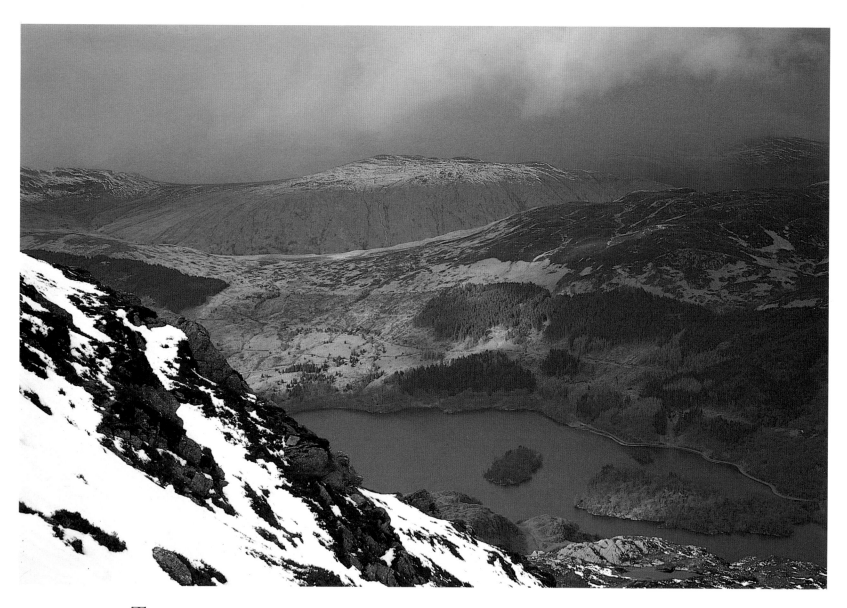

The Trossachs. Loch Katrine with the small tree-covered island of Eilean Molach seen from Ben Venue

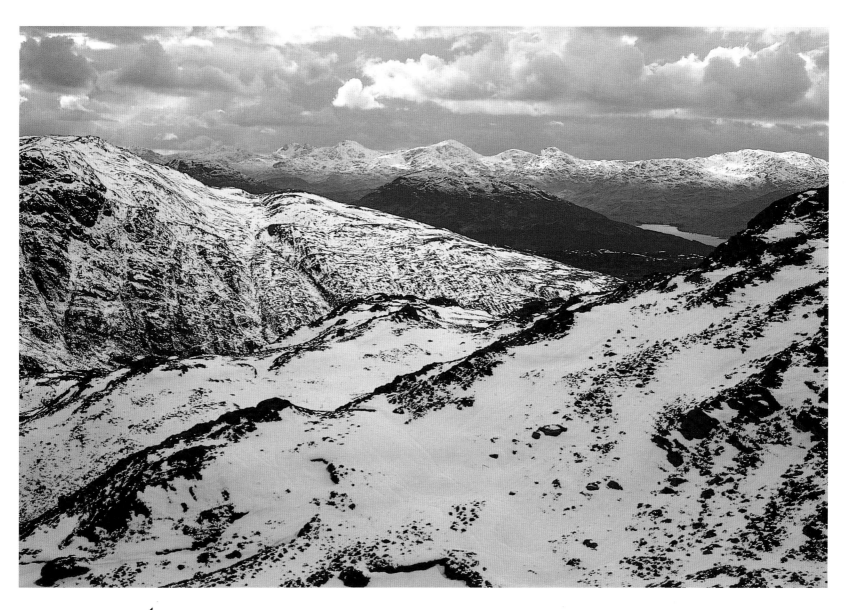

A cold hand on the Trossachs – Ben Venue with Ben Lomond in the distance across Loch Ard Forest

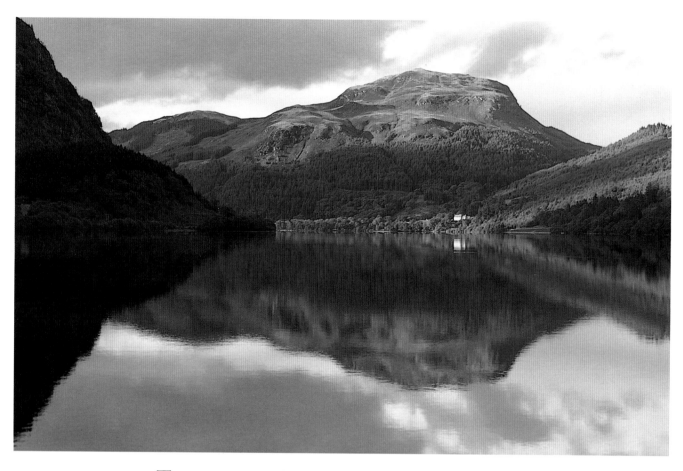

The still waters of Loch Lubnaig below Strathyre, The Trossachs

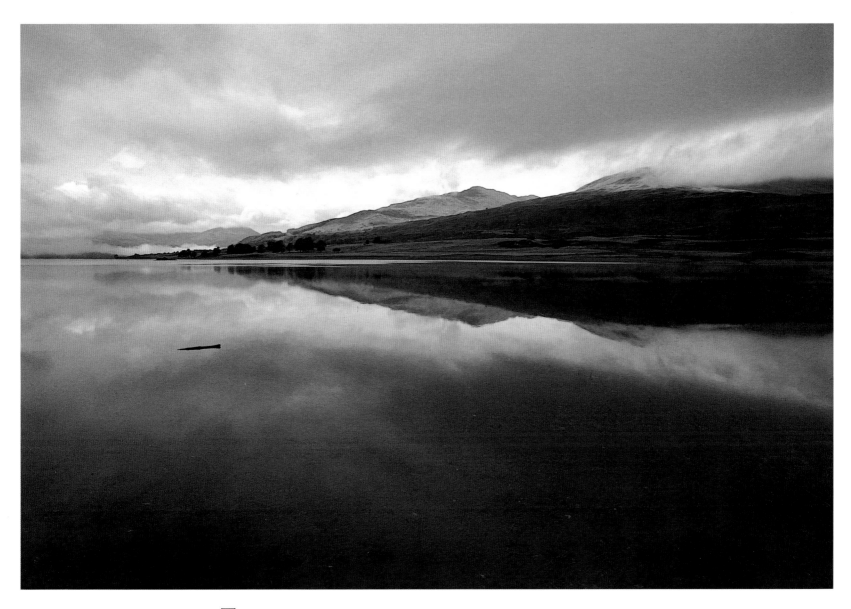

The Trossachs – Loch Vennachar and the Menteith Hills at dawn

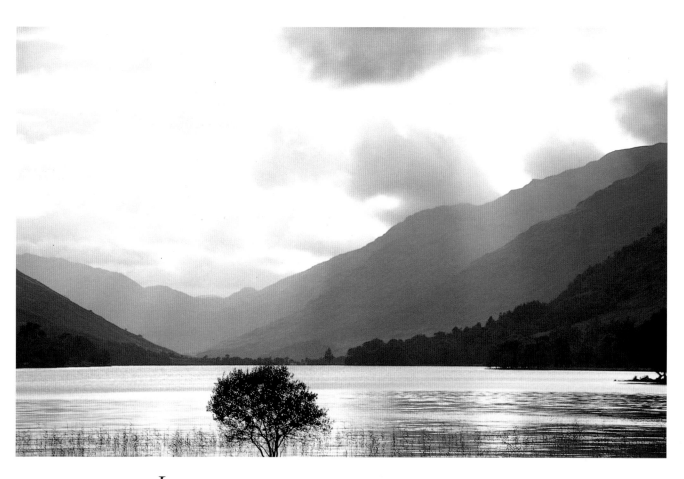

Loch Voil: a veil of water drawn from the Braes of Balquhidder

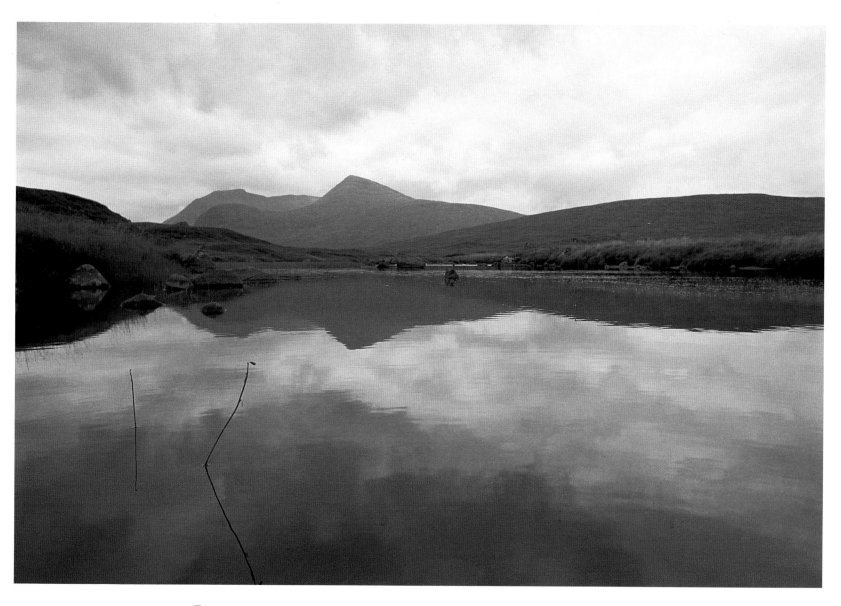

Lochan Na Stainge on the Black Mount: 'the windy graveyard under Clachlet'

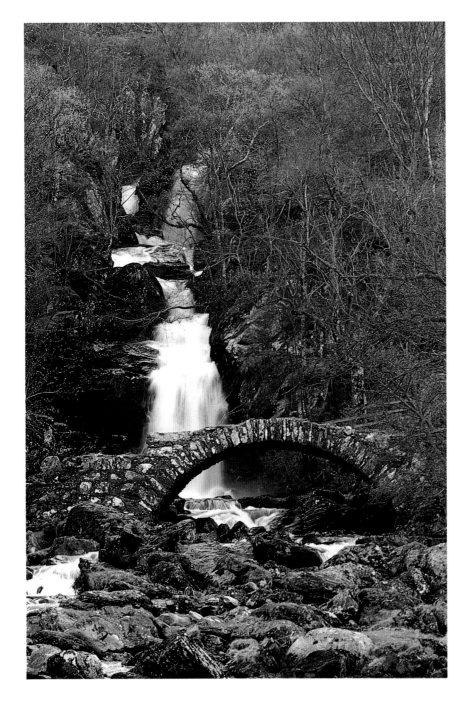

Waterfall leading down to Glen Lyon.
'The white cascade that's both a bird and star'.
W H DAVIES

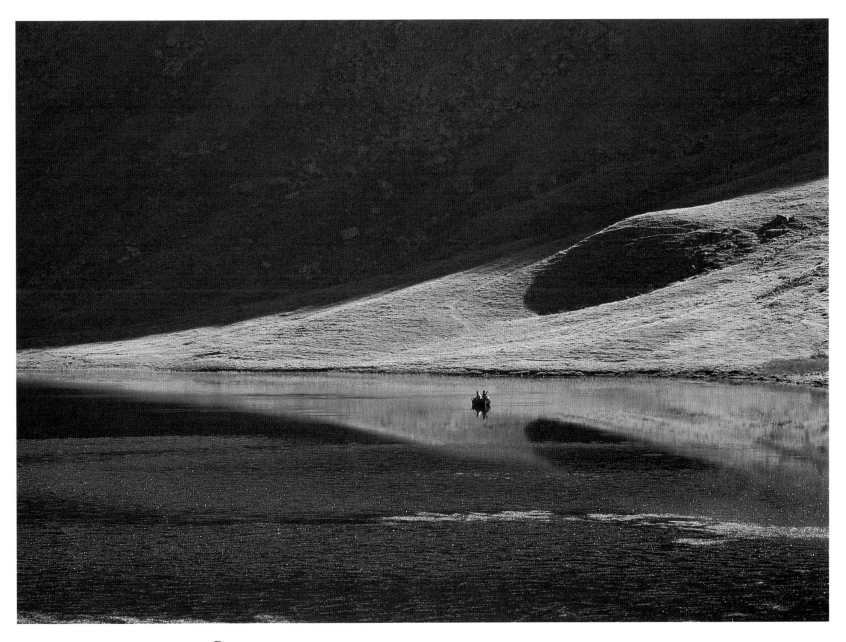

Glencoe: Loch Achtriochtan on the peaceful green flats below Aonach Dubh

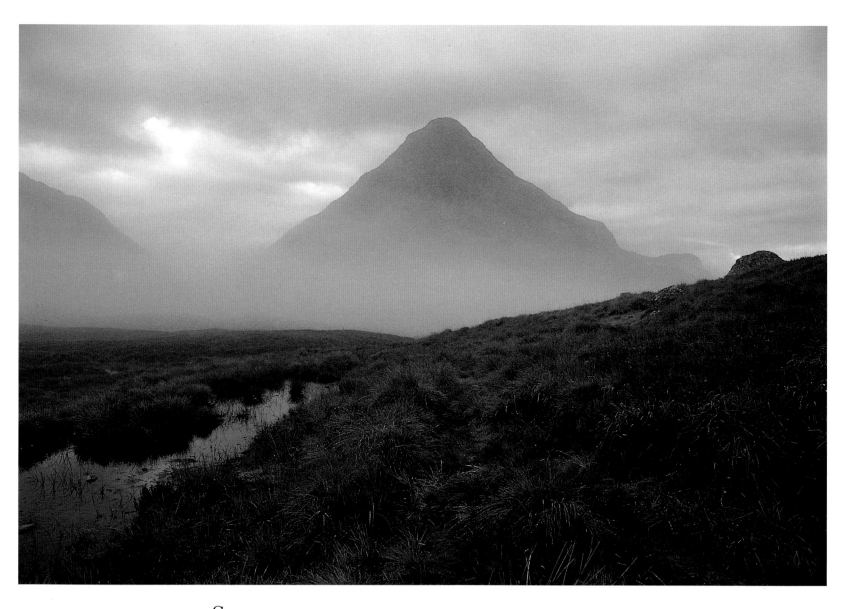

Stob Dearg, Buachaille Etive Mor: the Great Herdsman of Etive, Glencoe

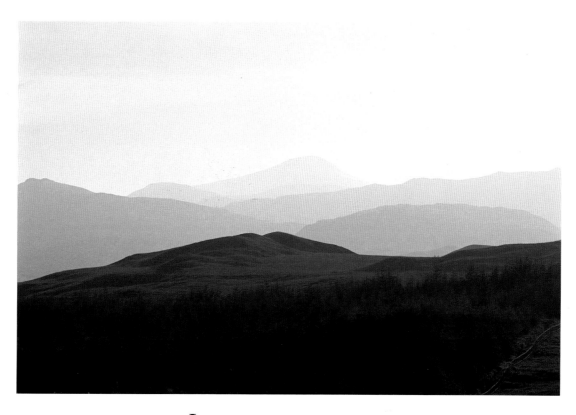

Lorn Mountains across Ardchattan

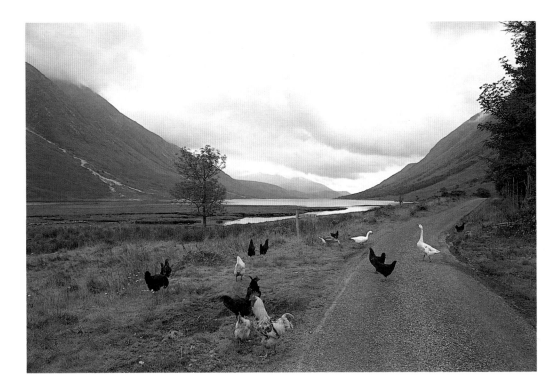

Passing place on the Glen Etive road

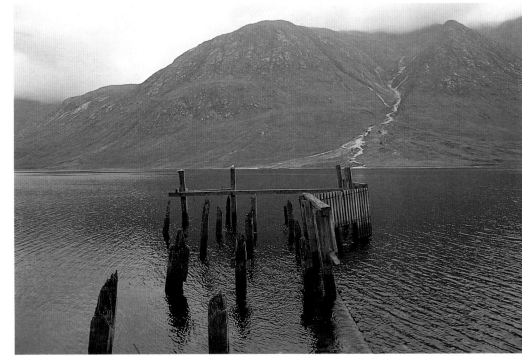

Loch Etive side – beloved home of Deirdre NicCruithnigh, 'Deirdre of the Sorrows', who was banished to Ireland to marry the King of Ulster. She died of a broken heart

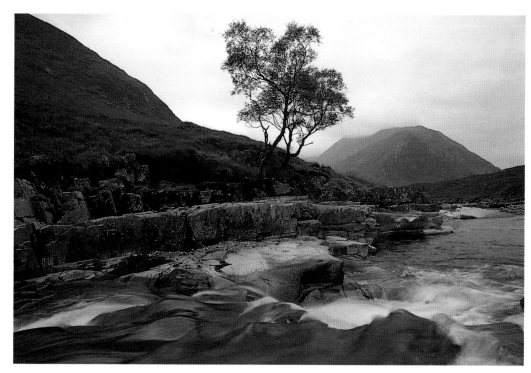

The River Etive, drained from the Black Corries of Rannoch Moor

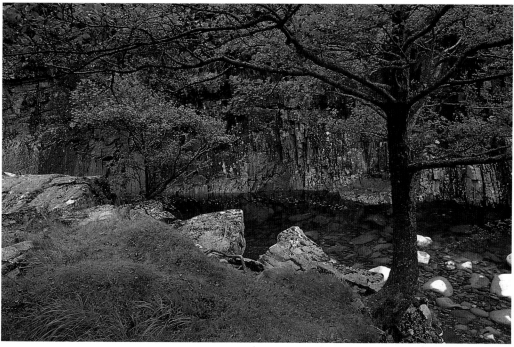

Peat-brown water and the green banks of the River Etive

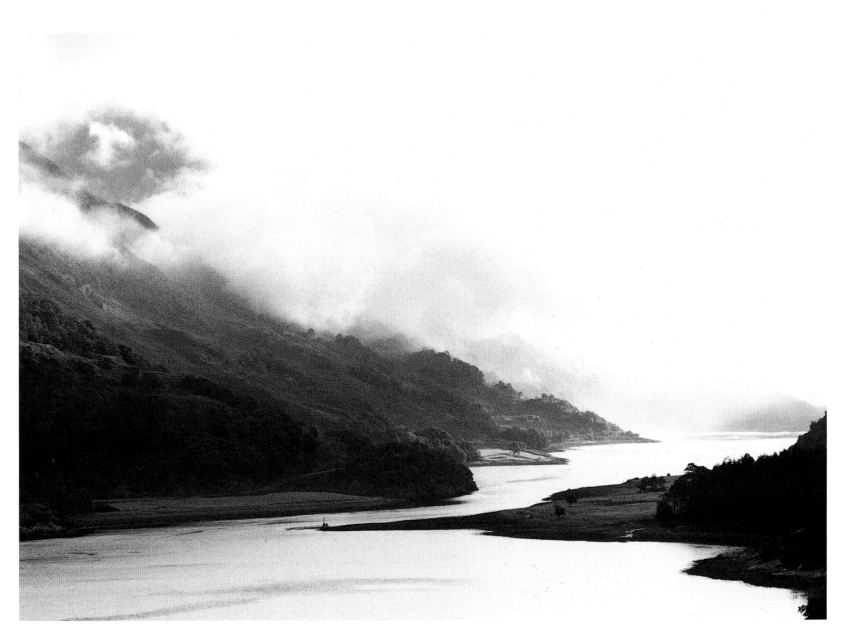

Loch Leven: low cloud lying

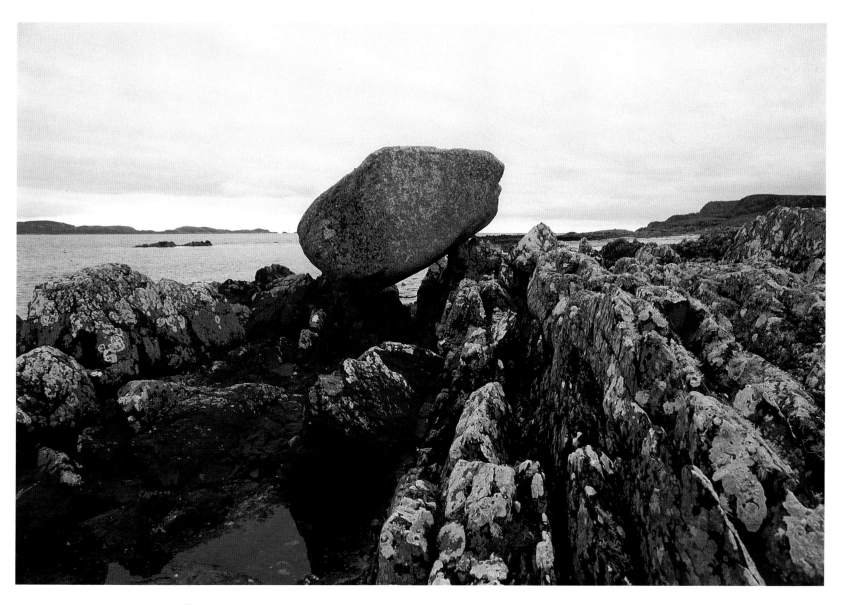

*Iona: Port Nam Mairtir. Martyr's Bay, where sixty-eight monks were slaughtered
by Viking raiders in 806*

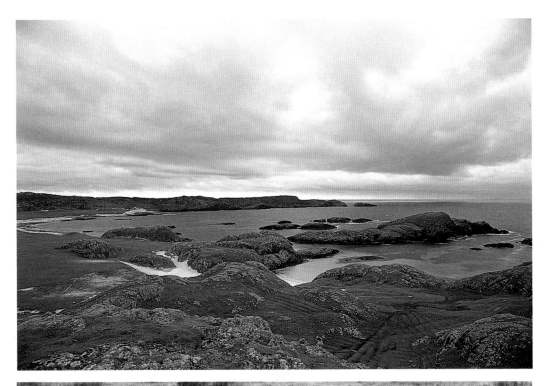

Port a Shoirtein Bhig, Iona with the outlines of disused plots called feannagan or 'lazy-beds' clearly seen in the green hollows

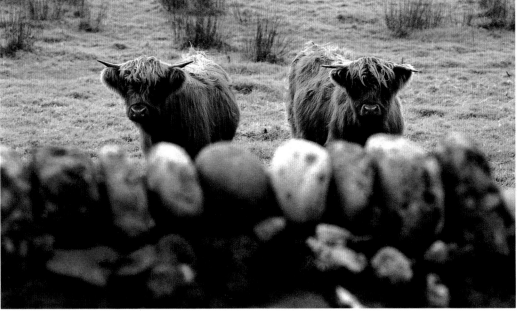

Highland cattle consider the camera

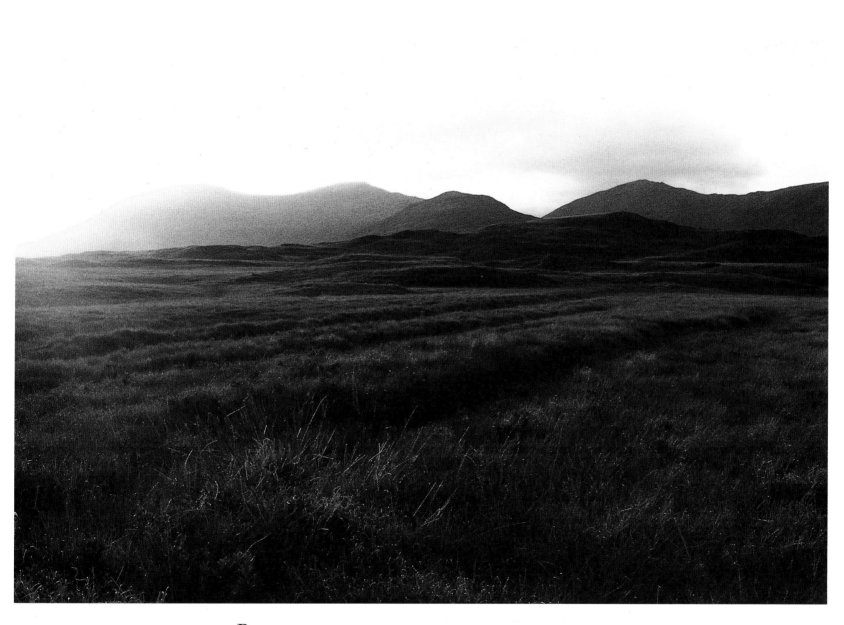

Blanket bog in the long, lonely reaches of Glen More, Isle of Mull

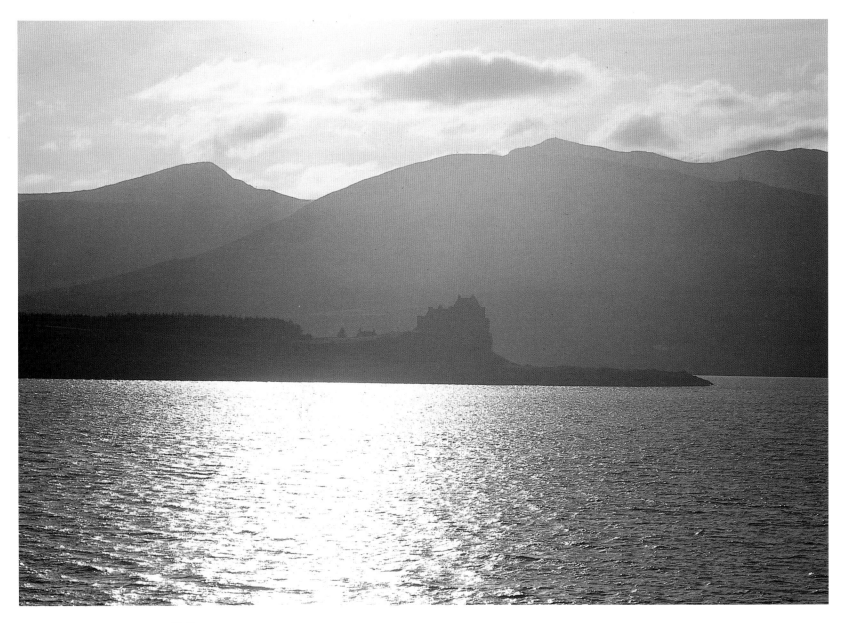

Mull: the thirteenth-century Duart Castle on the 'black height' above the Firth of Lorn

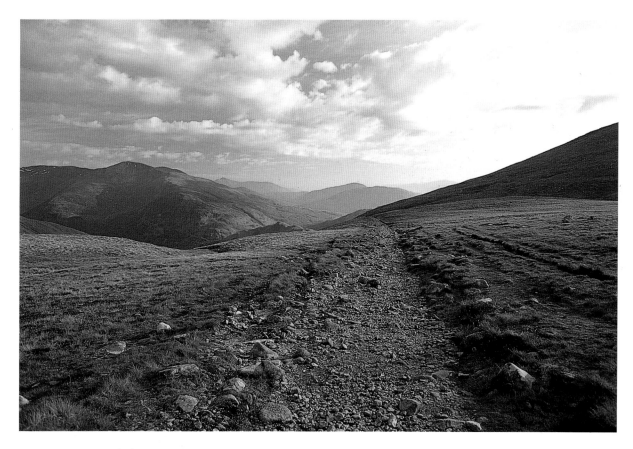

The open road: looking south from Glen Nevis towards Sgorr Chalum

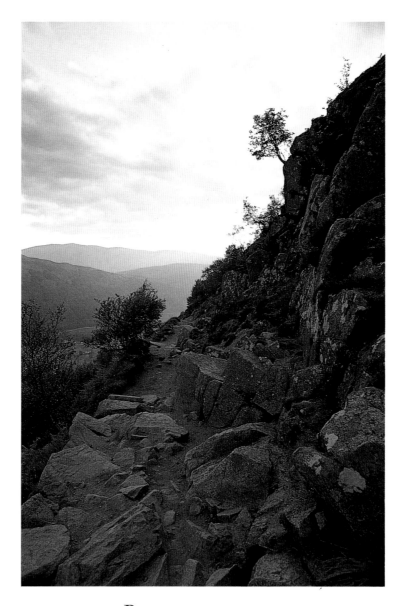

Rough passage on Ben Nevis

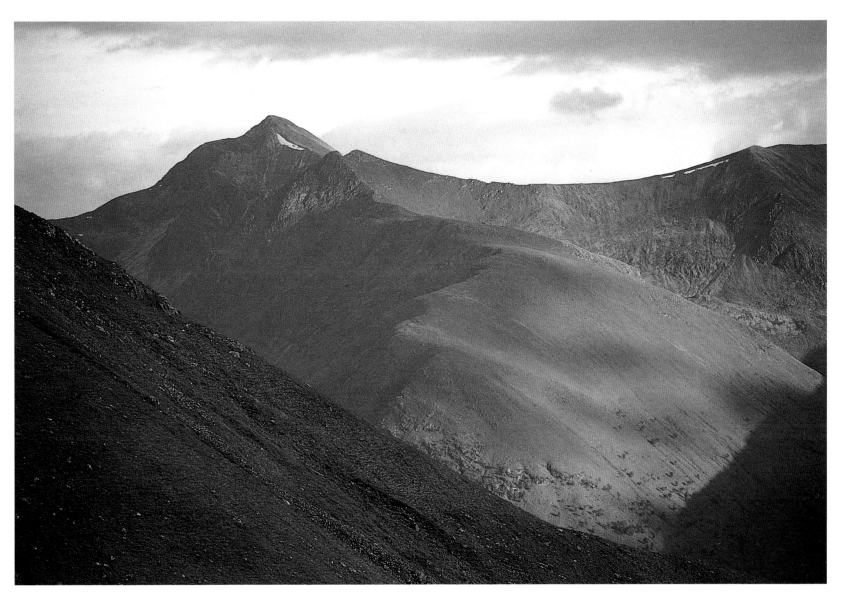

Sgurr a Mhaim – 'the crag of the pass', second highest peak of the Mamores, south of Ben Nevis

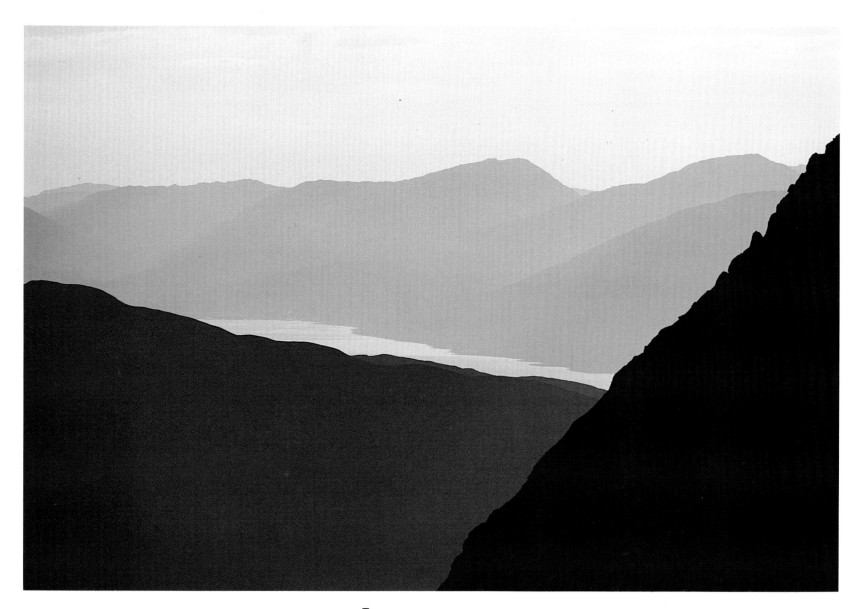

Loch Eil from Ben Nevis

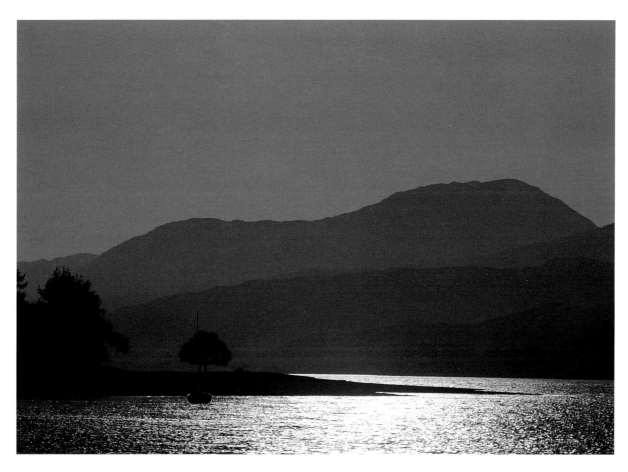

Still night and moonlight on Loch Eil

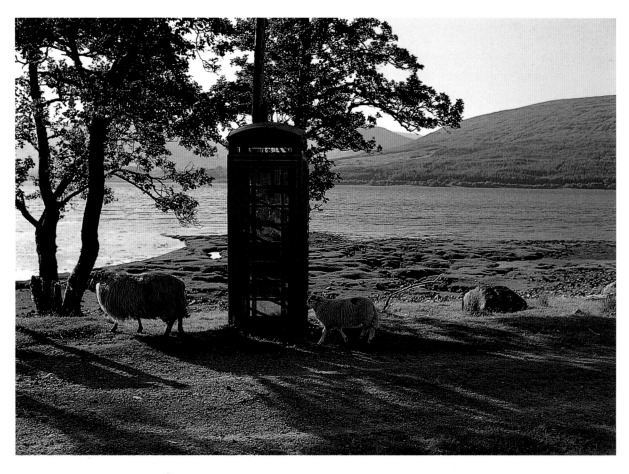

Call of the wild at Blaich, on Loch Eil's southern shore

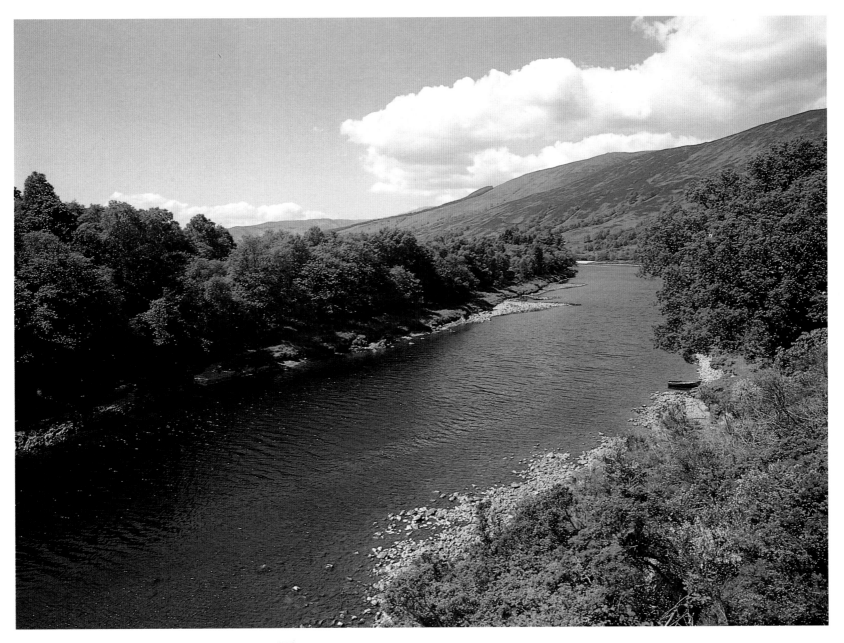

The snow-fed waters of the River Spean, Lochaber

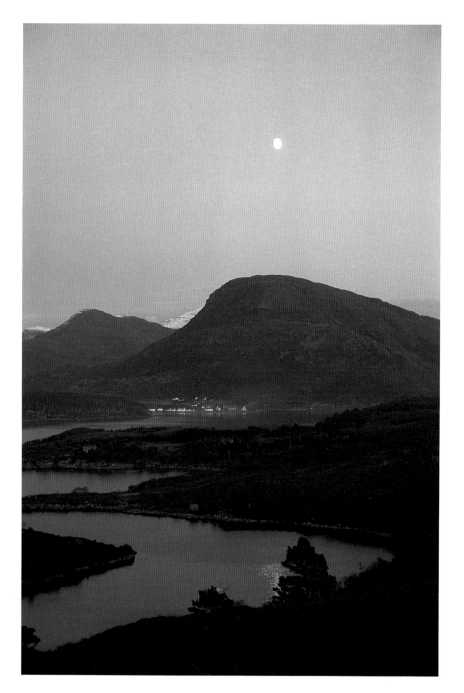

Shieldaig village below Ben Shieldaig,
Wester Ross

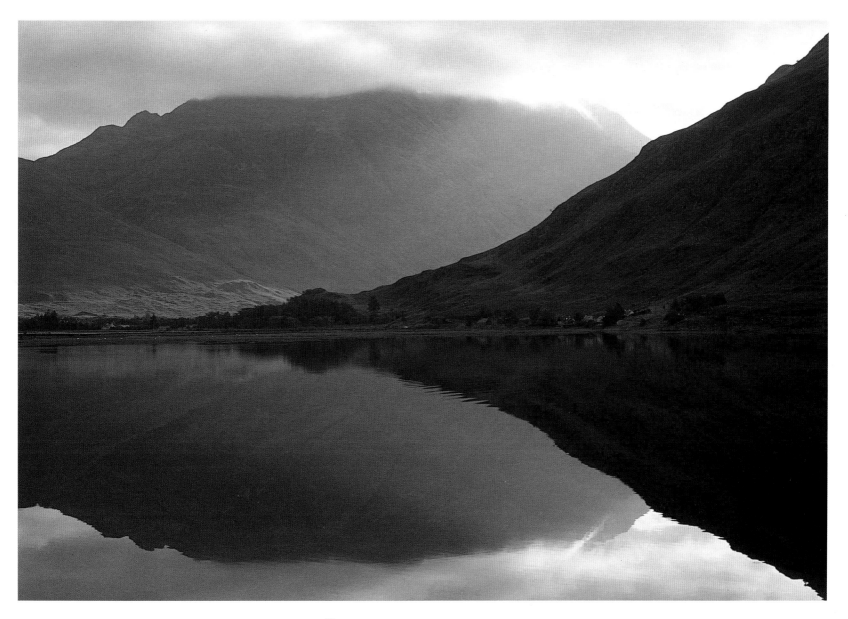

Loch Duich on the Road to the Isles

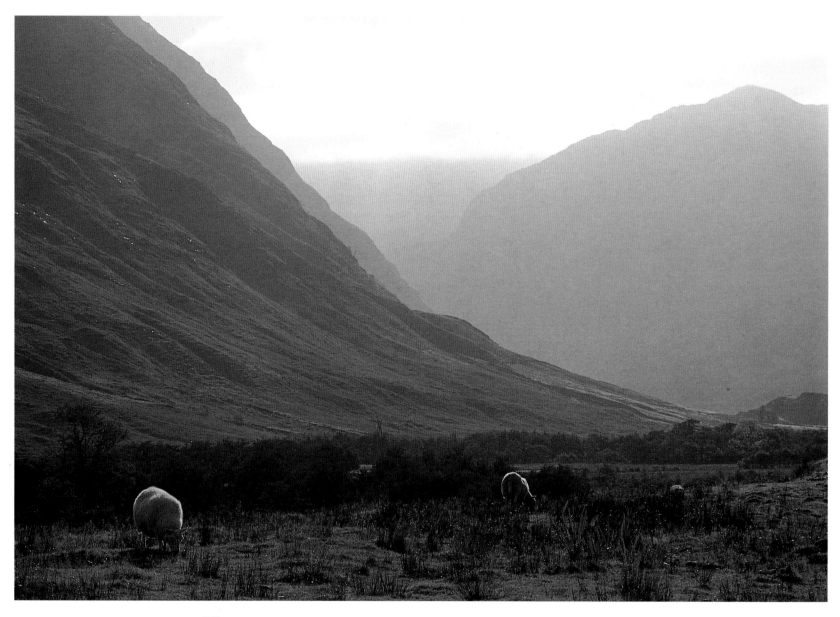

The great pass of Glen Shiel with Kintail and the Five Sisters to the north

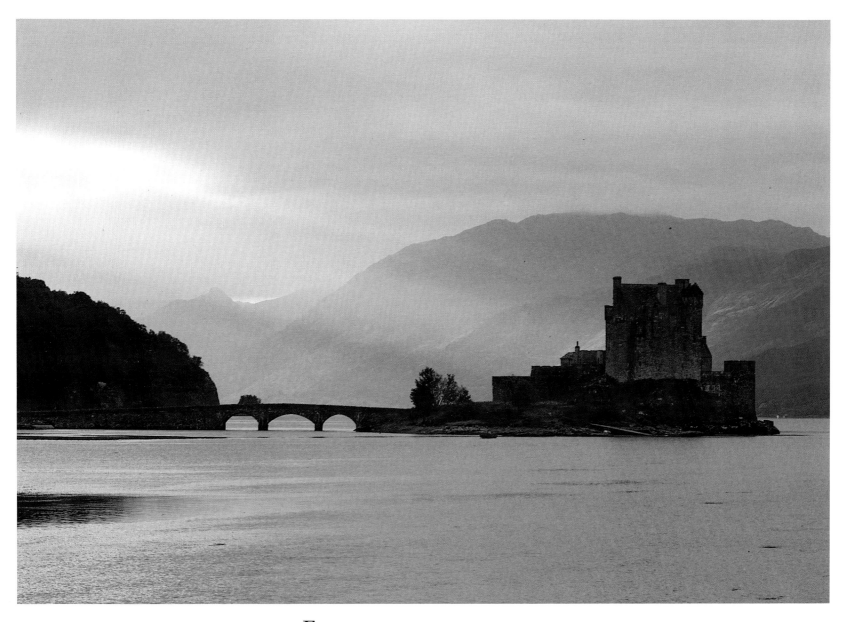

Eilean Donan Castle, Loch Duich, Kintail

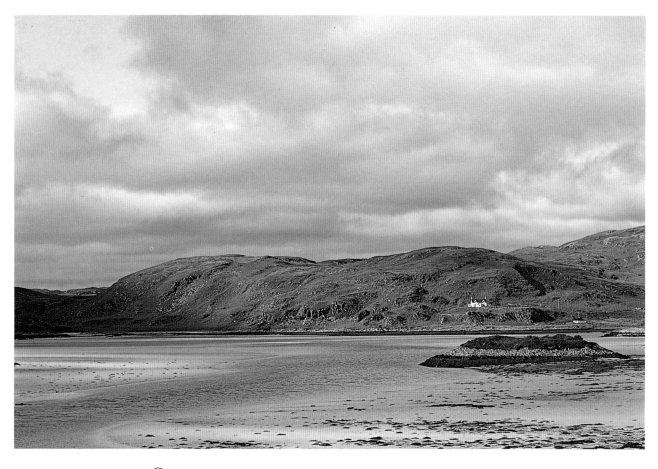

Sgeir Mhor, near Mallaig where the short-lived River Morar
breaches the sands to the Sound of Sleat

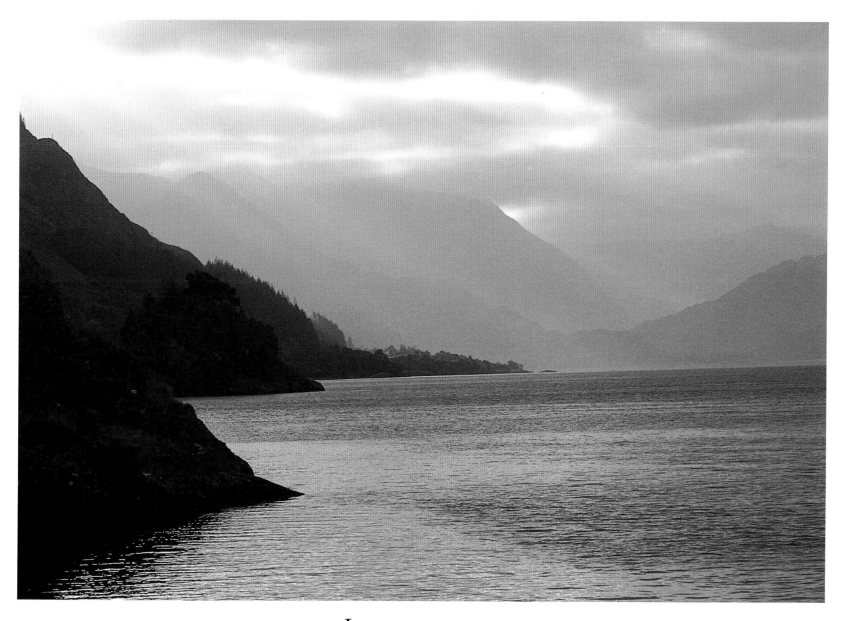

Loch Alsh in the amber dusk

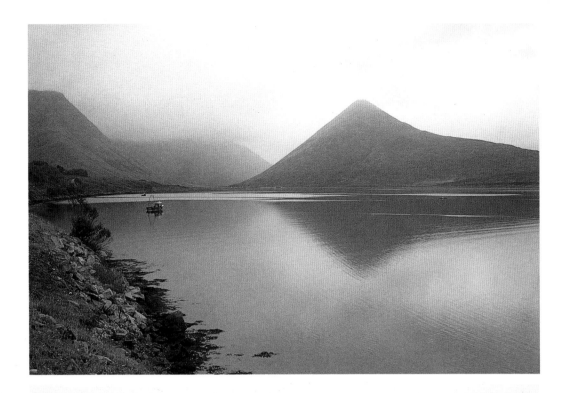

Beinn Dearg Mhor, the Great Red Peak, above the head of Loch Slapin, Skye

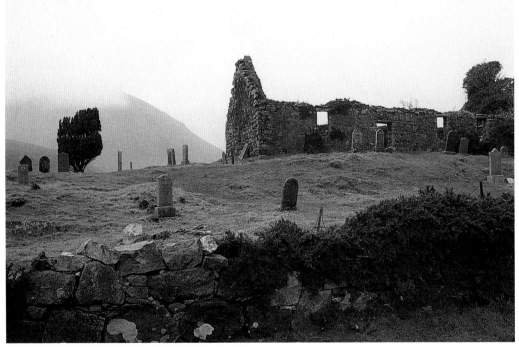

Cill Chriosd, the Mackinnon Graveyard, in Strath Suardal, Skye

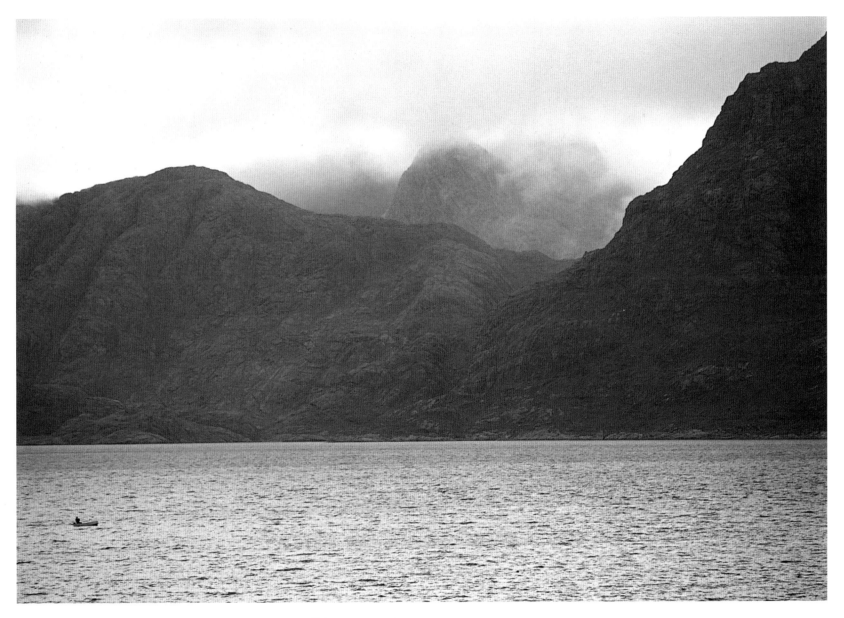

The Black Cuillin across Loch Scavaig.
'The breaking of mists from the Garsven's head creeping over desolate summits . . .'
SORLEY MACLEAN

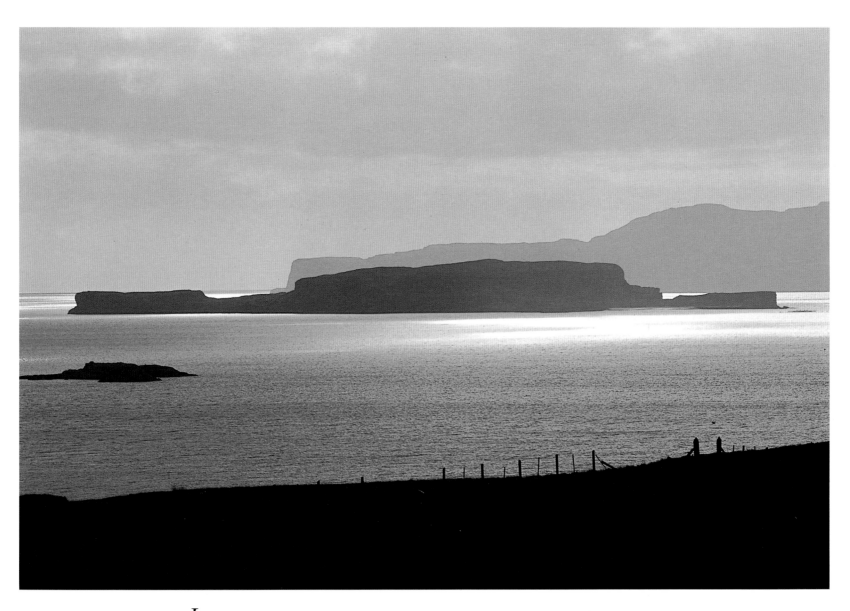

Loch Bracadale looking towards Idrigill Point and beyond to the Sea of the Hebrides

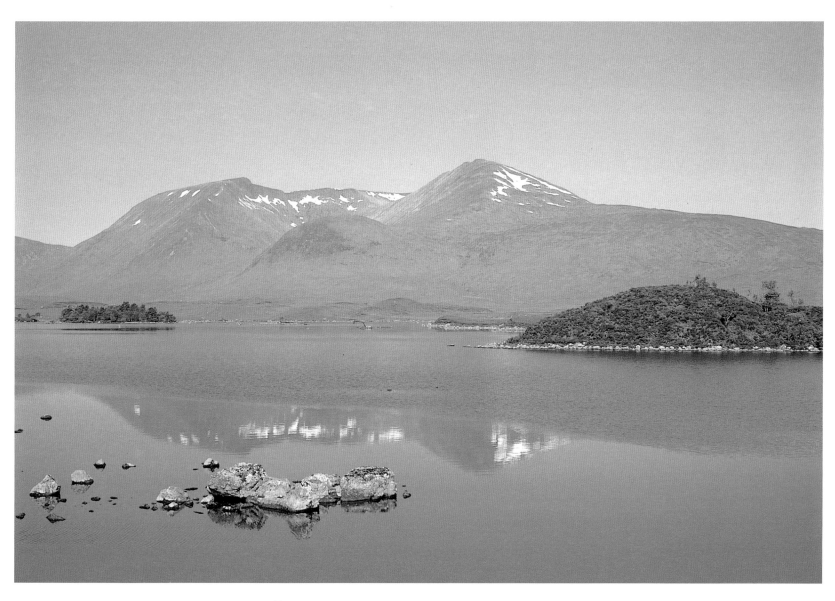

Island of Raasay seen from Skye across the Narrows

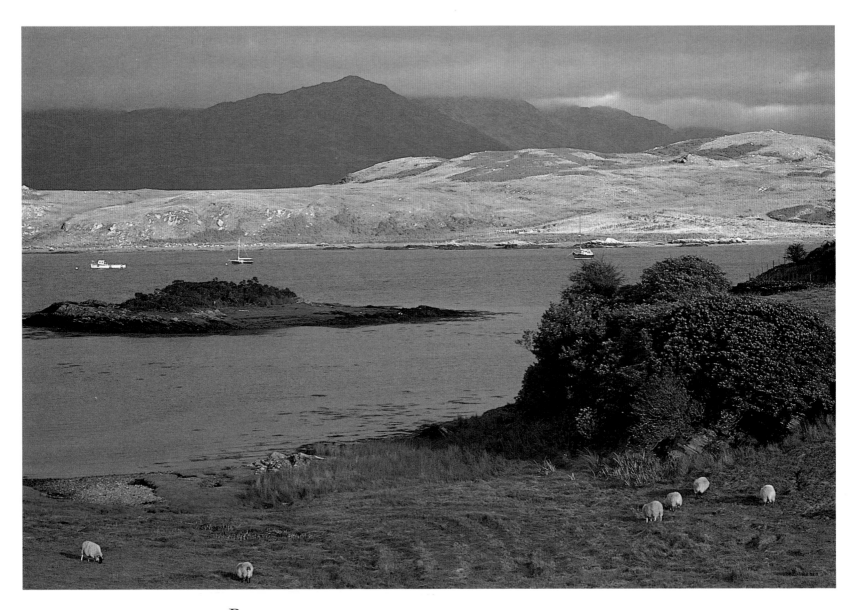

Blue distance. Looking across to Raasay from the Sligachan shore, Skye

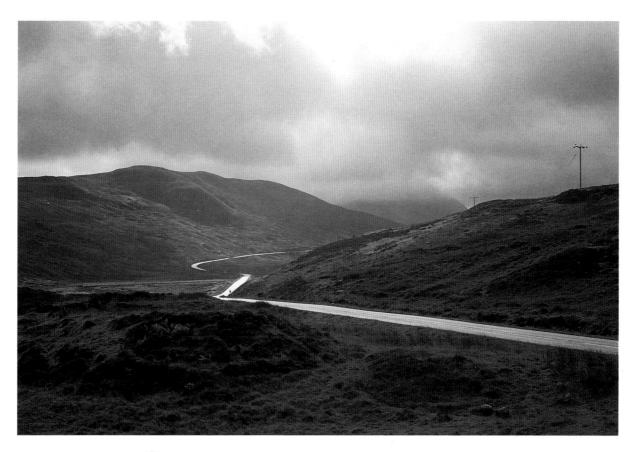

Glen Torra-mhichaig below Glamaig, the Red Cuillin, Skye

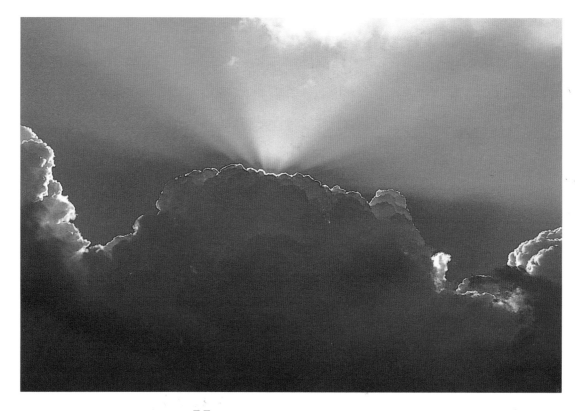

Hebridean sky – mountain mirror

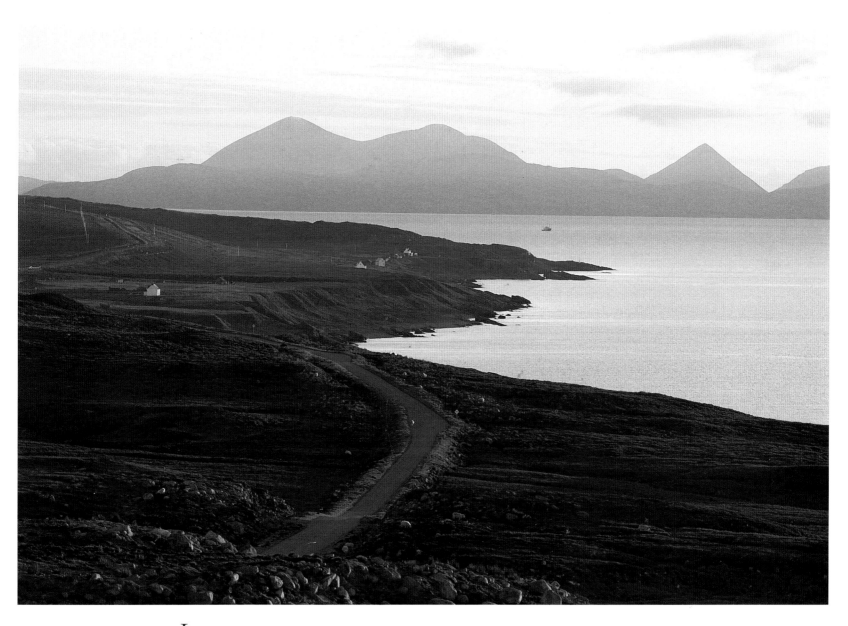

Looking across the Inner Sound towards Skye from Rubha Chuaig, North Applecross

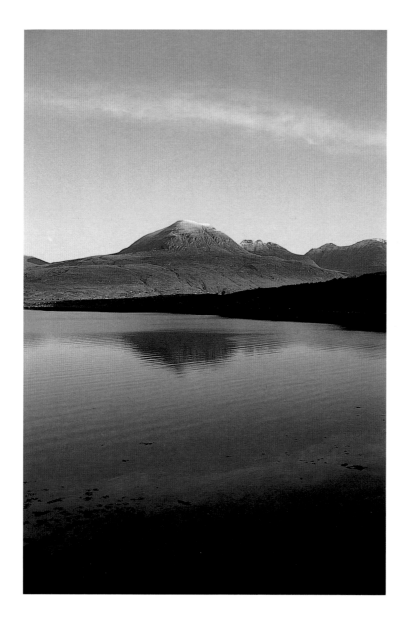

Looking across upper Loch Torridon towards Beinn Alligan, named from the Gaelic ailleag, *the jewel*

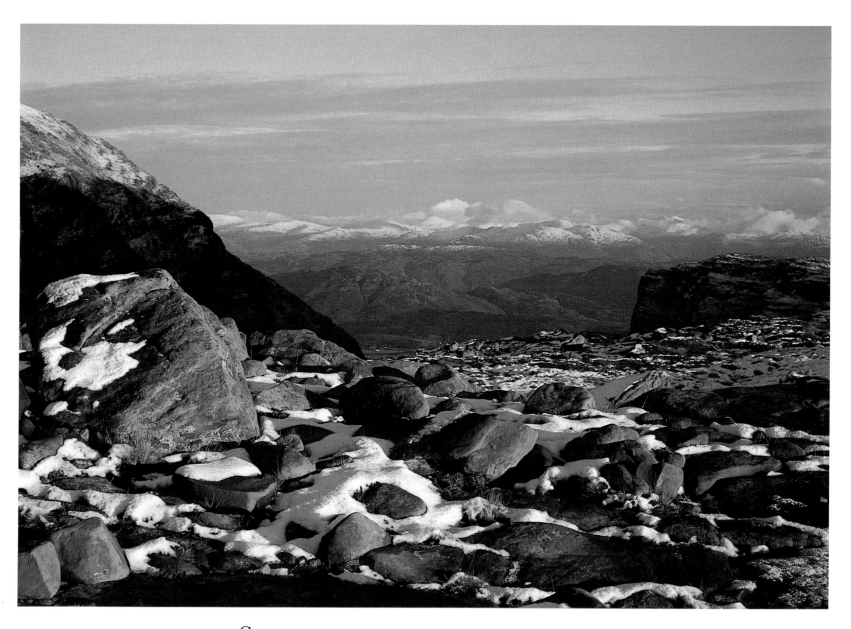

Stone ground, stone cold: on Meall Gorm, Applecross, Wester Ross

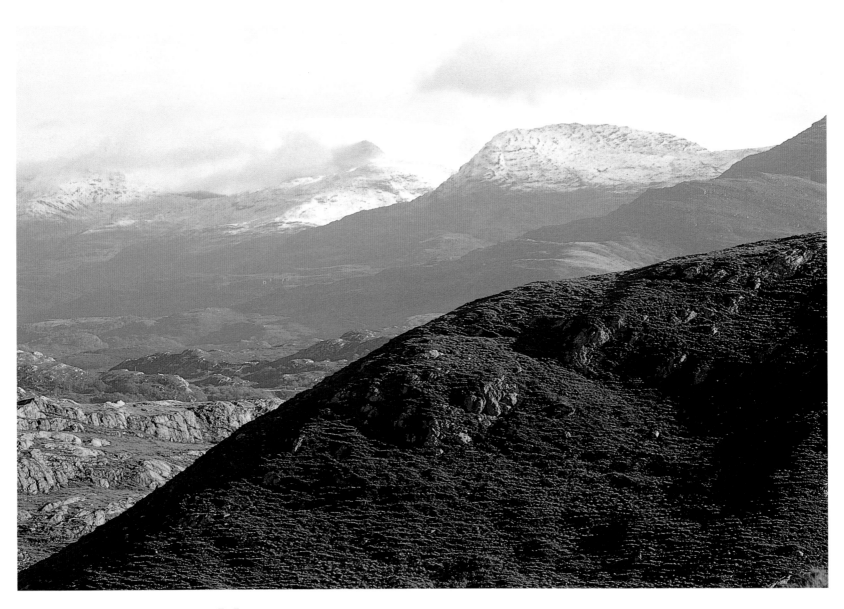

Moulded by the cutting edge of ice and water: the hard hills of Torridon

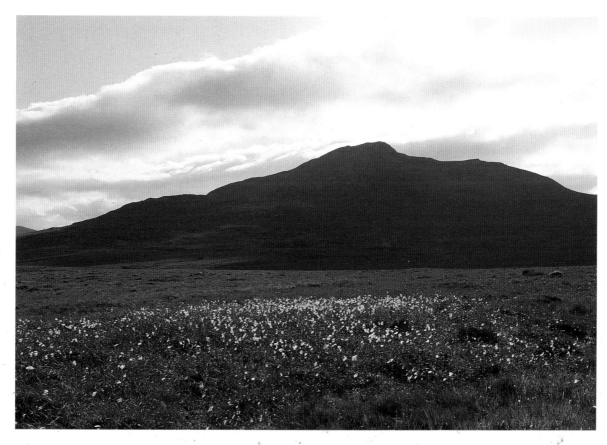

Cotton grass below the dark brow of Glaic Buidhe, Wester Ross

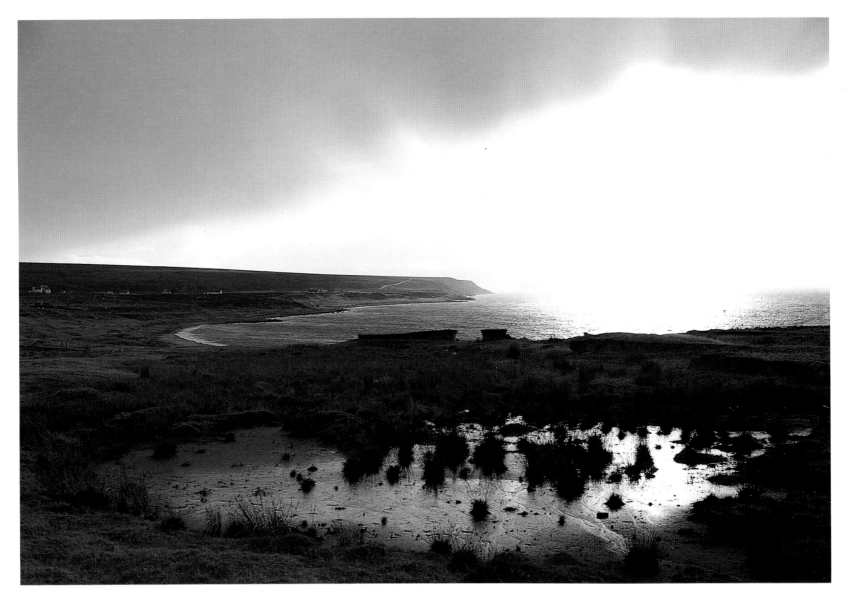

Opinan in the parish of Gairloch. Crofting country on the sand-blown headlands of Wester Ross

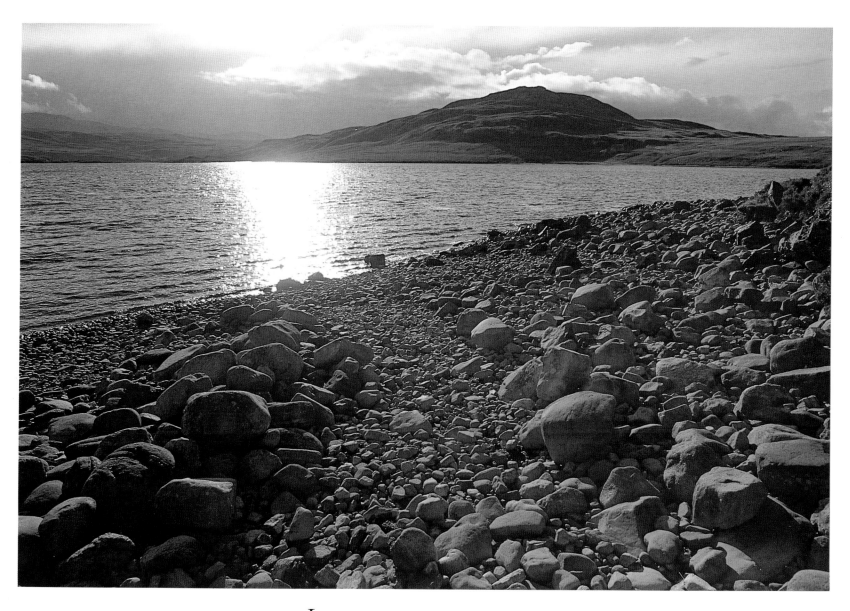

Loch Clair in the Coulin Forest, Torridon

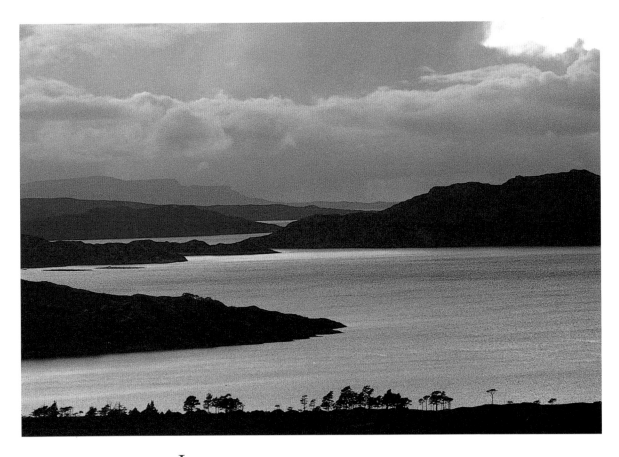

Interlocking land and sea at the heart of Loch Torridon

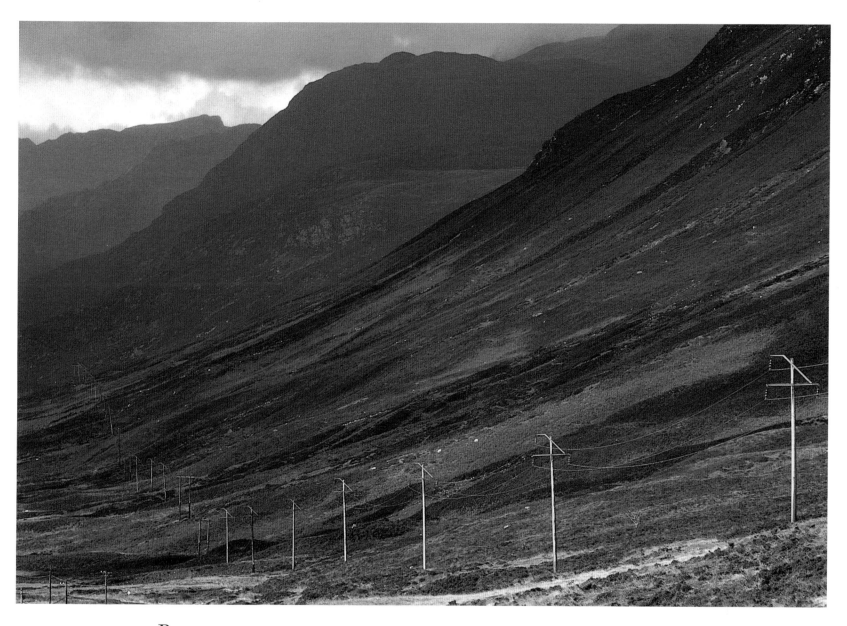

Power lines overpowered by the landscape in Glen Docherty on the road east from Kinlochewe and Loch Maree

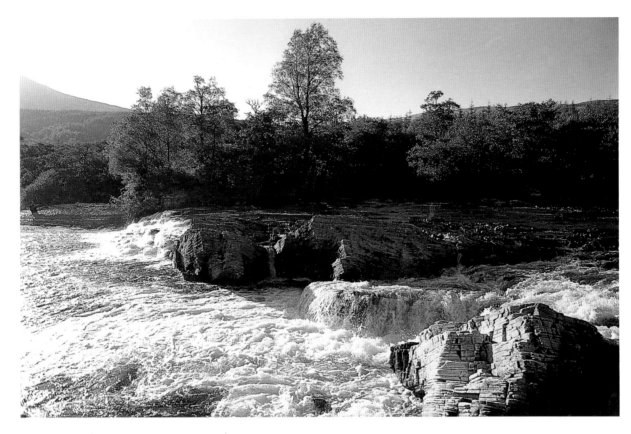

A typical highland stream brimming with life.
'*W*hat would the world be once bereft,
of wet and wildness …'

GERARD MANLEY HOPKINS

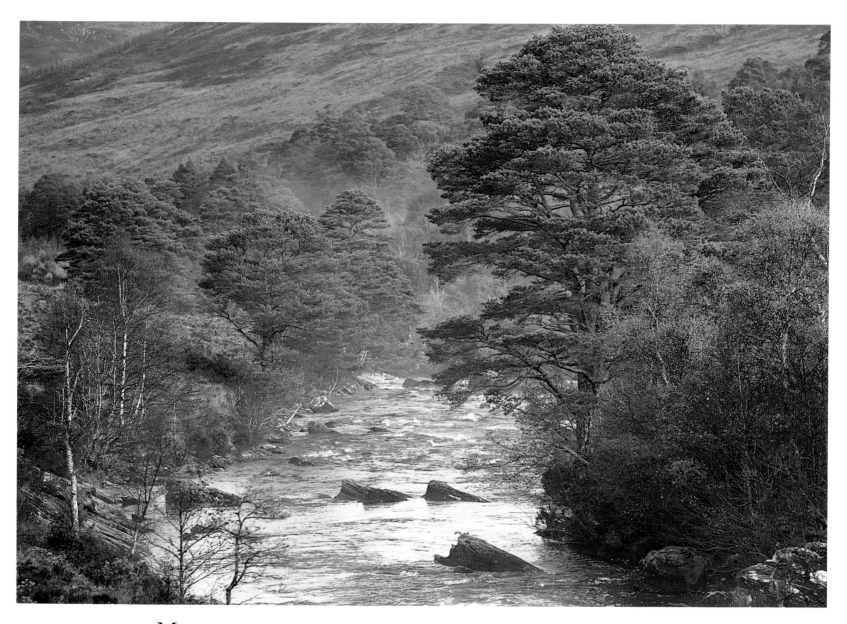

Morning mists rising from A Ghairbhe, Glen Torridon, 'the place of transference', from the Gaelic Toirbheartan *marking the ancient portage from Loch Torridon to Loch Broom*

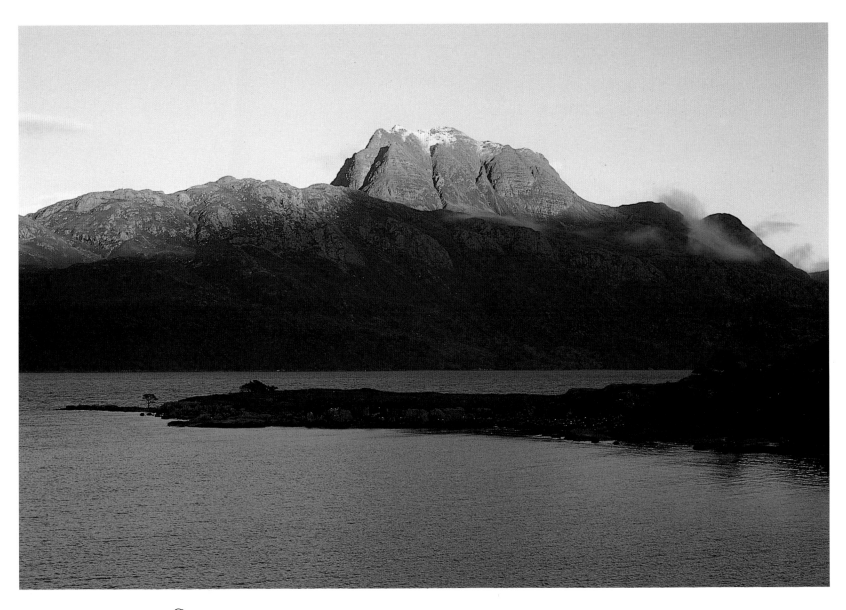

Slioch, 'the spear', above Loch Maree. The southern bulwark of a magnificent wilderness running north through Achaniasgair to the Road of Desolation at Dundonnell

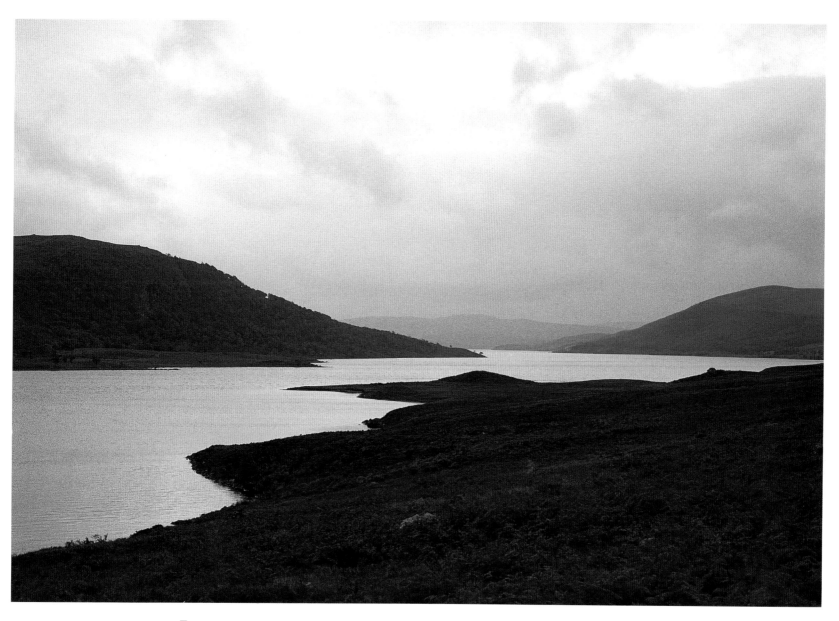

Loch Naver, Sutherland, a bittersweet emptiness. Strathnaver was cleared for sheep in the early nineteenth century

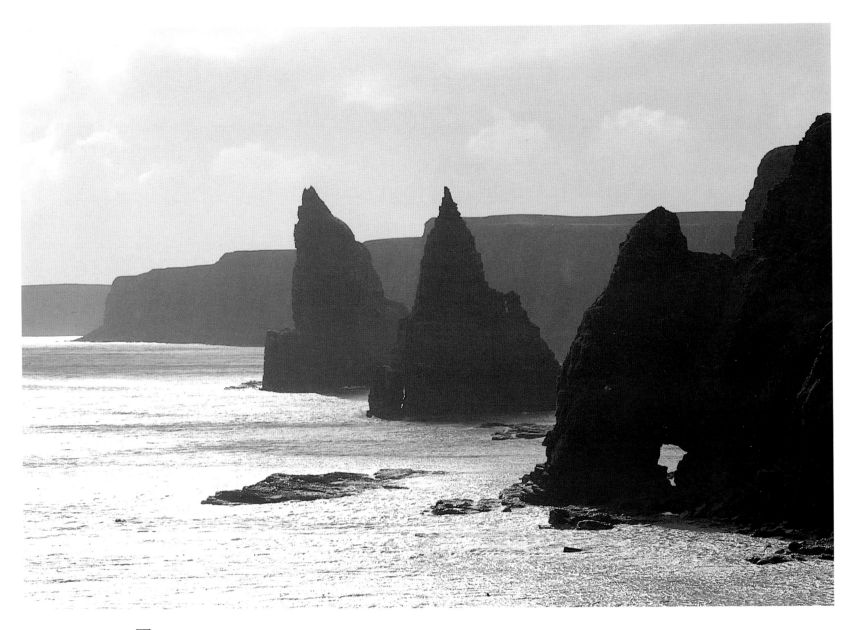

The Stacks of Duncansby south of Duncansby Head, with the Muckle and Peedie (big and little), stacks rising to over two hundred and fifty feet (seventy-six metres) in height

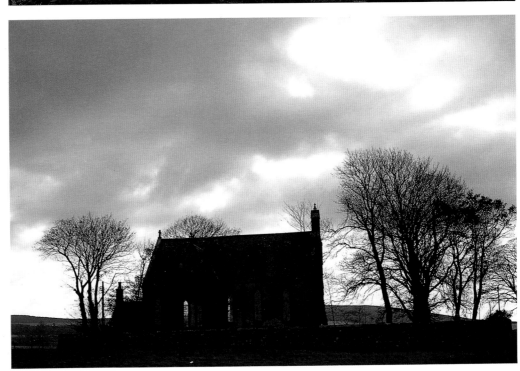

Harthill church 'at the back o' Bennachie', Aberdeenshire

St John's church, Deskford, Banffshire

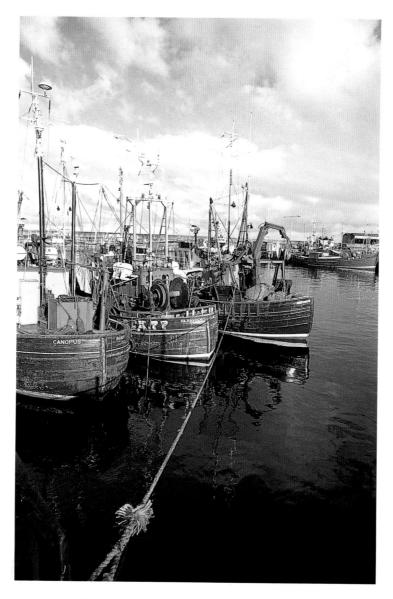

Business in great waters – hard-worked trawlers in Buckie harbour

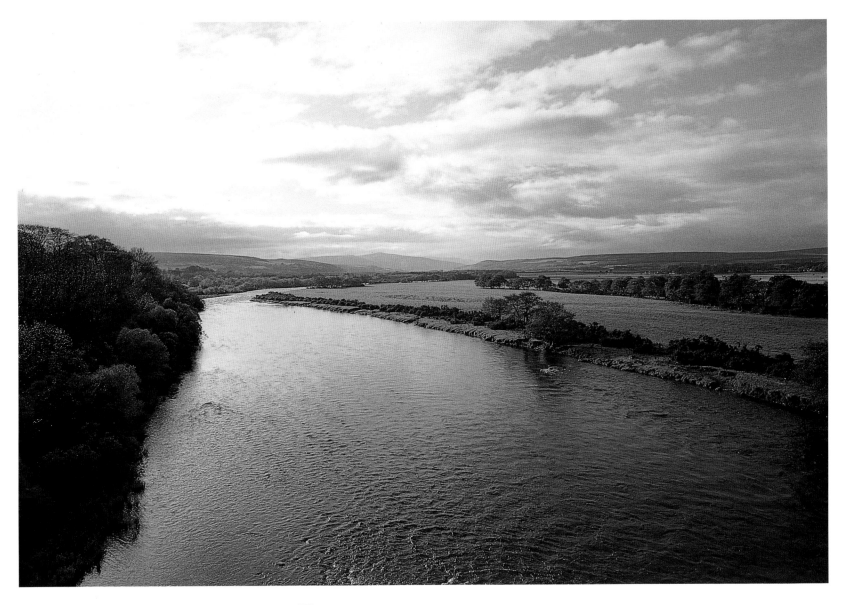

The River Spey: peace beyond the mountains

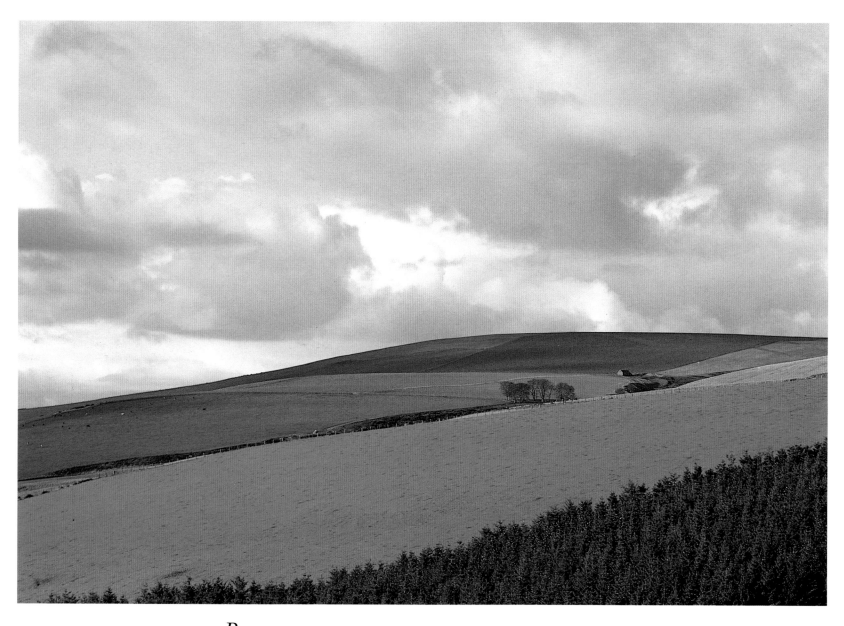

Buchan farmlands: a green place between the mountains and the sea

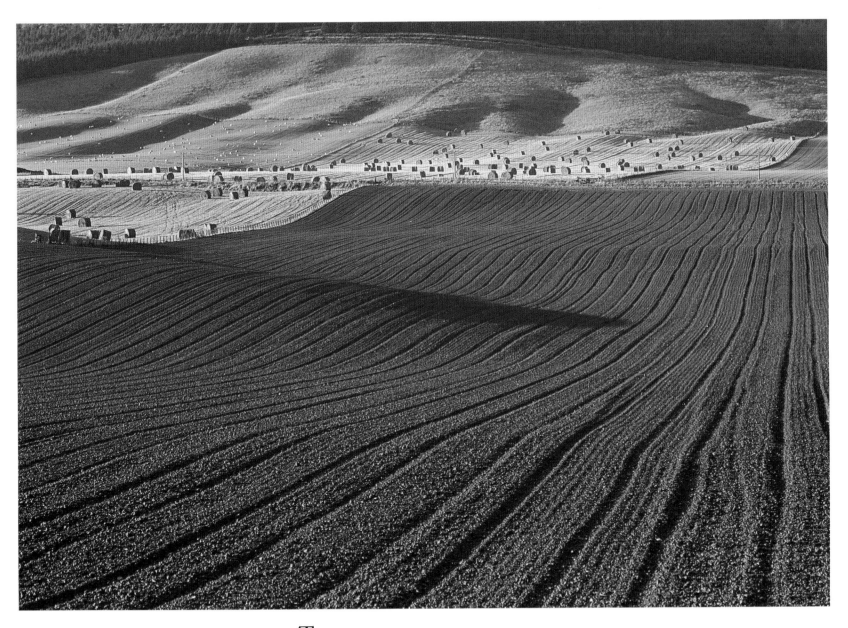

The rich red clay of the Howe o' the Mearns

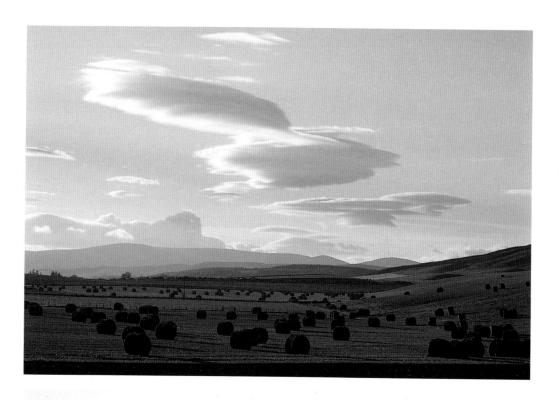

Strathmore: the great plain flanked by the spring-line foothills of the Grampians

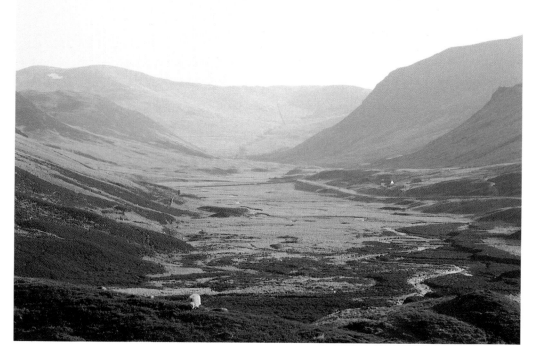

Glen Beg from The Cairnwell south of Braemar

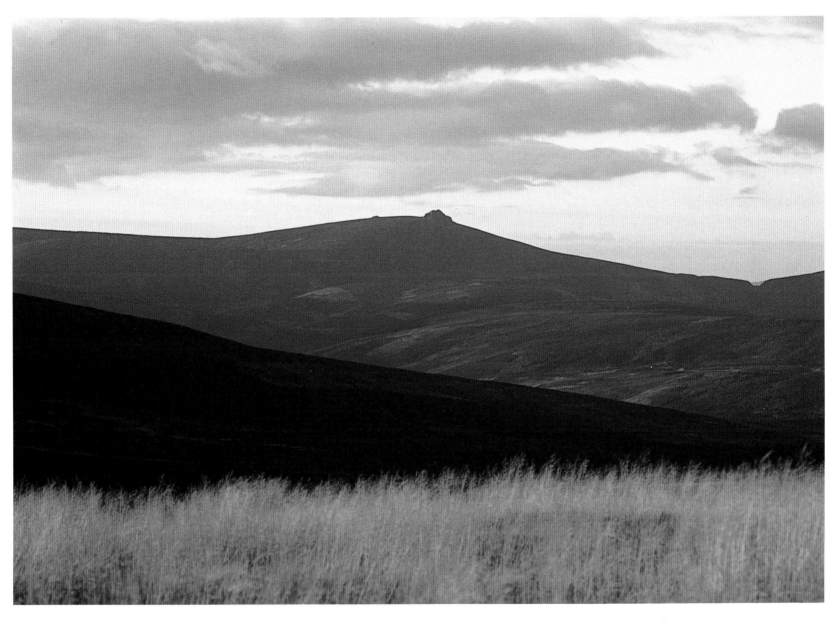

Clachnaben above Glen Dye near Banchory – legendary burial place of the Devil's wife, crushed beneath the great 'stone of the mountain'

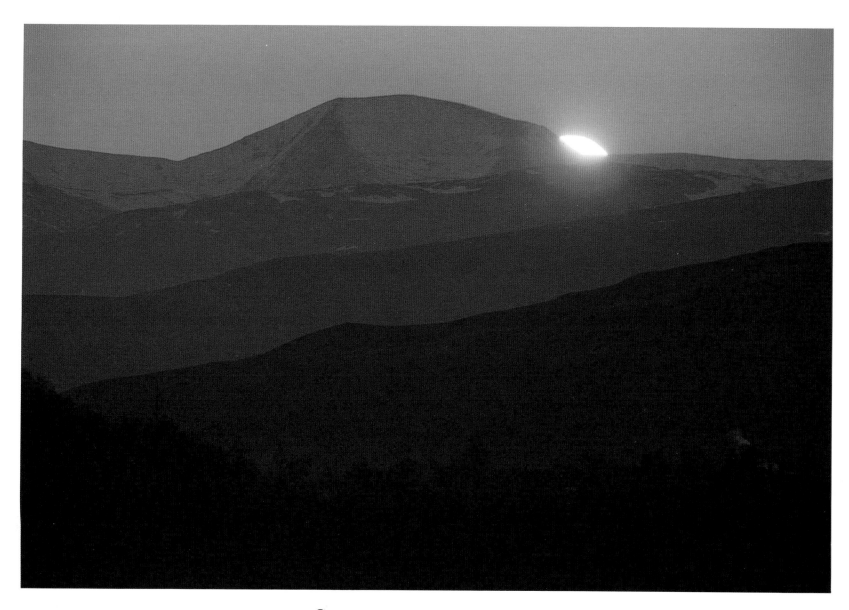

Sunset over the Cairngorms, Braemar
'Through the trance of silence …'
ROBERT LOUIS STEVENSON

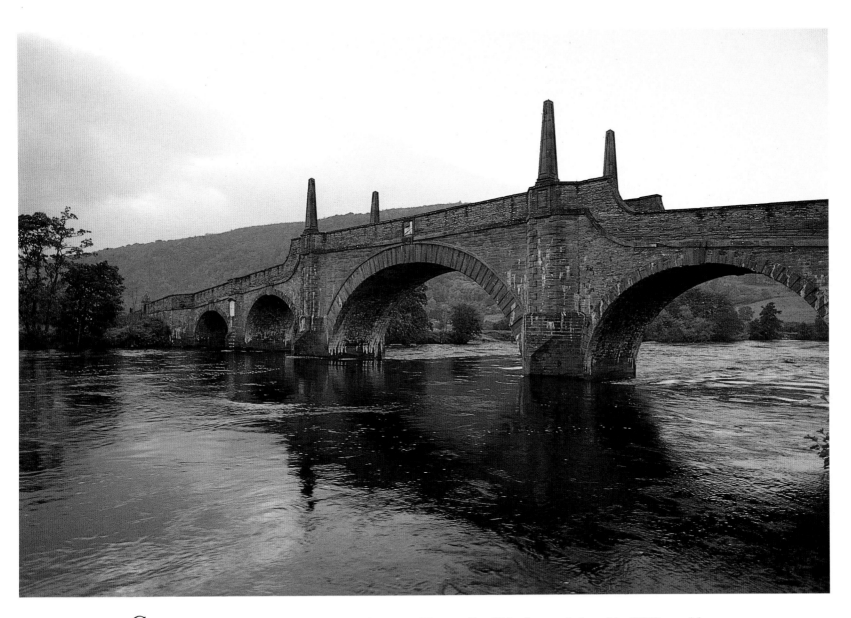

General Wade's finest bridge spanning the River Tay at Aberfeldy. It was designed by William Adam and completed in 1733

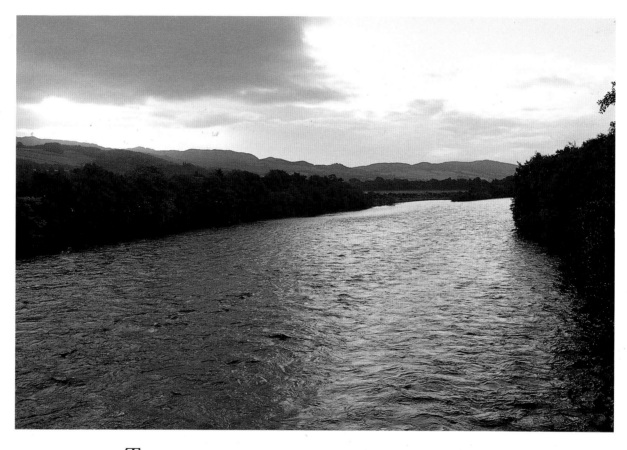

The River Tummel where it flows through the woods of Logierait
south of Pitlochry

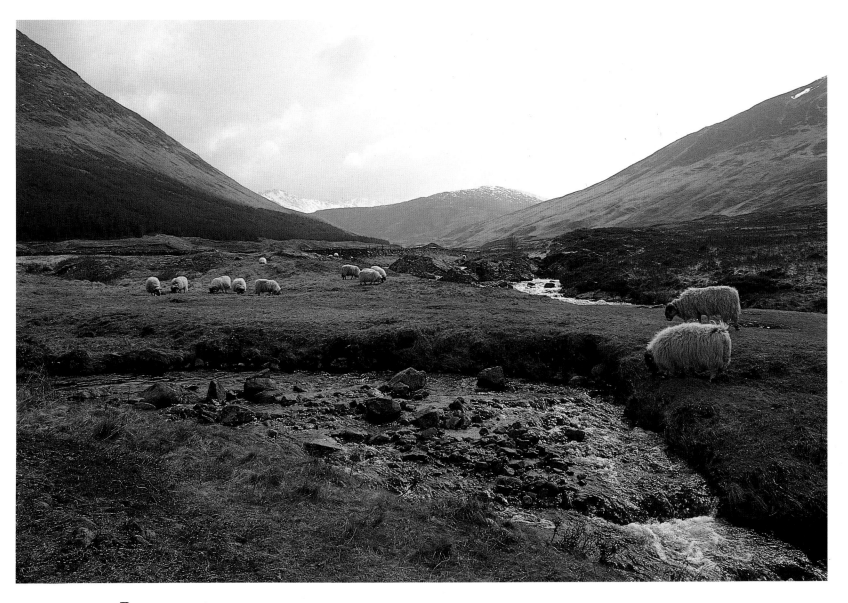

Rough grazing on the banks of the Allt Bail a Mhuilinn between Ben Lawers and Meall Nan Tarmachan

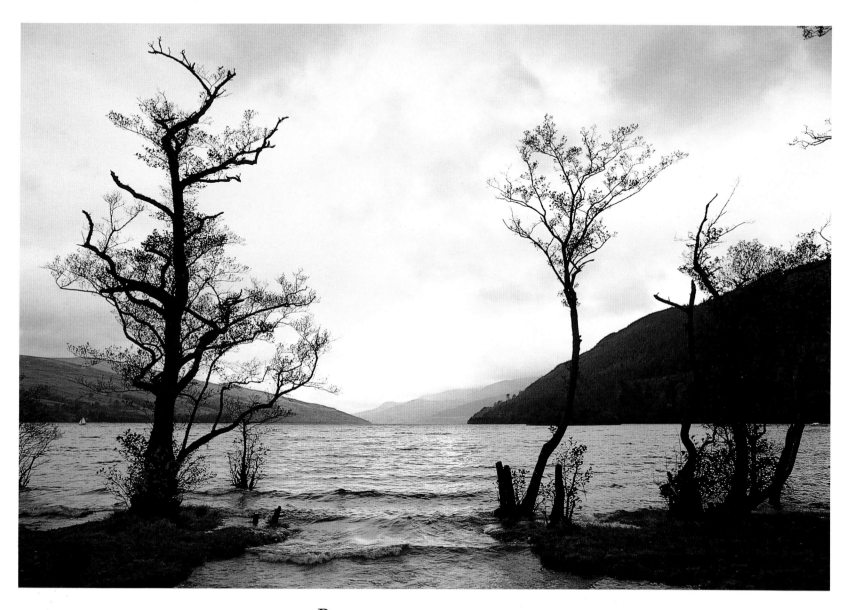

Roots of water: Loch Tay, Breadalbane

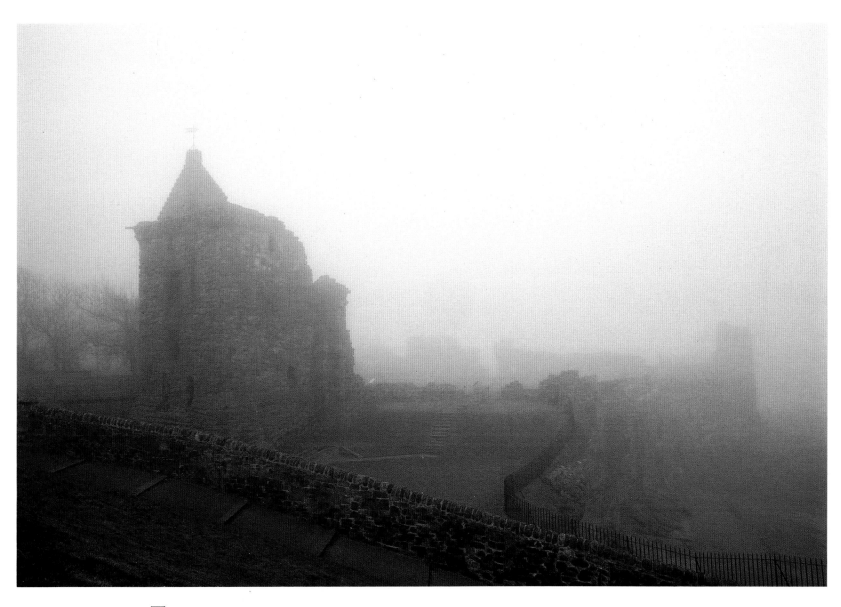

The Castle, St Andrews, 'where many of God's children had been imprisoned' said John Knox

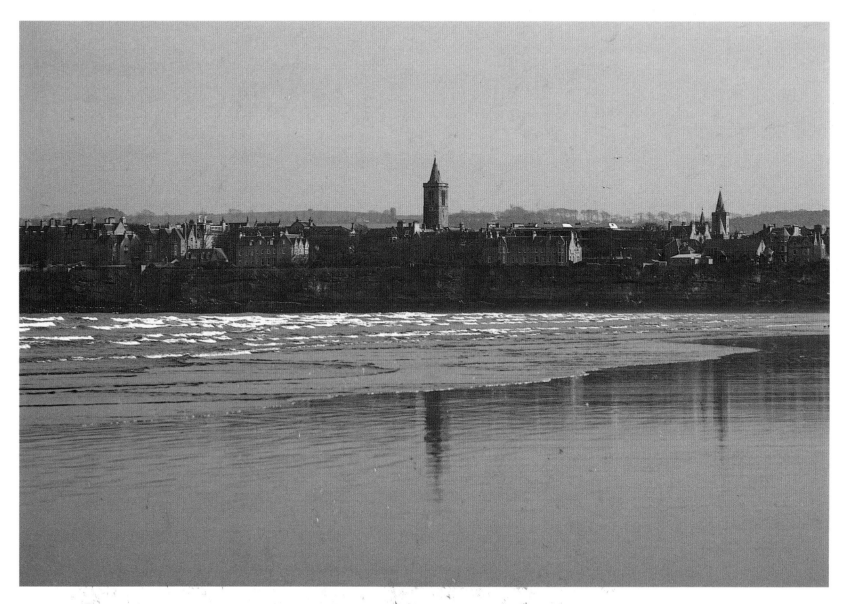

St Andrews across an ice-blue sea

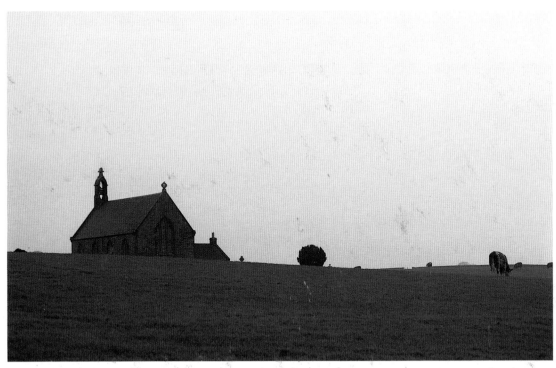

Church near Crail, East Fife. Simple, restrained expression of the Scottish way of worship

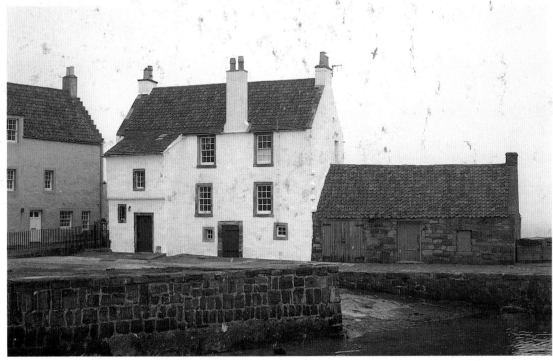

The Gyles, Pittenweem harbour, East Fife. Seventeenth-century vernacular architecture

95

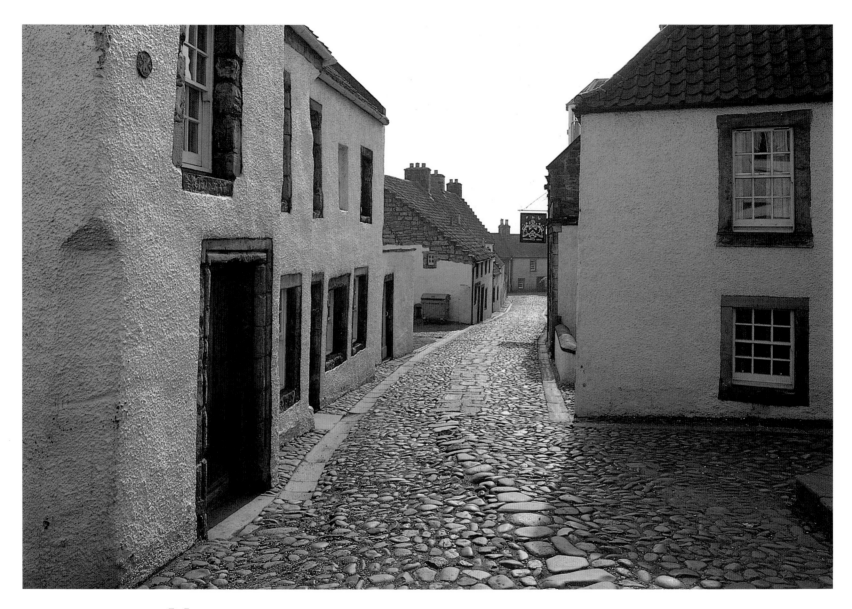

*M*id Causeway, Culross, Fife – sixteenth-century burgh architecture wonderfully preserved

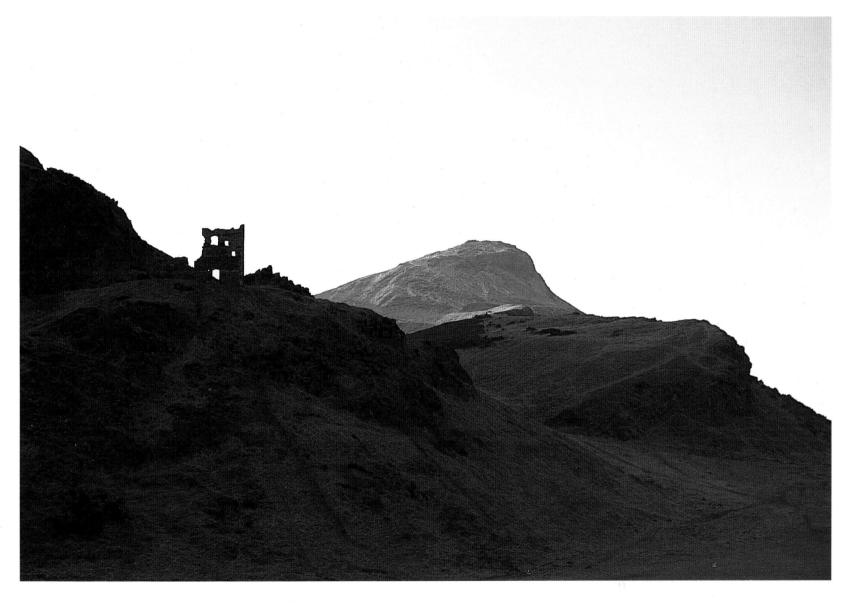

Edinburgh: Arthur's Seat on a cold clear morning

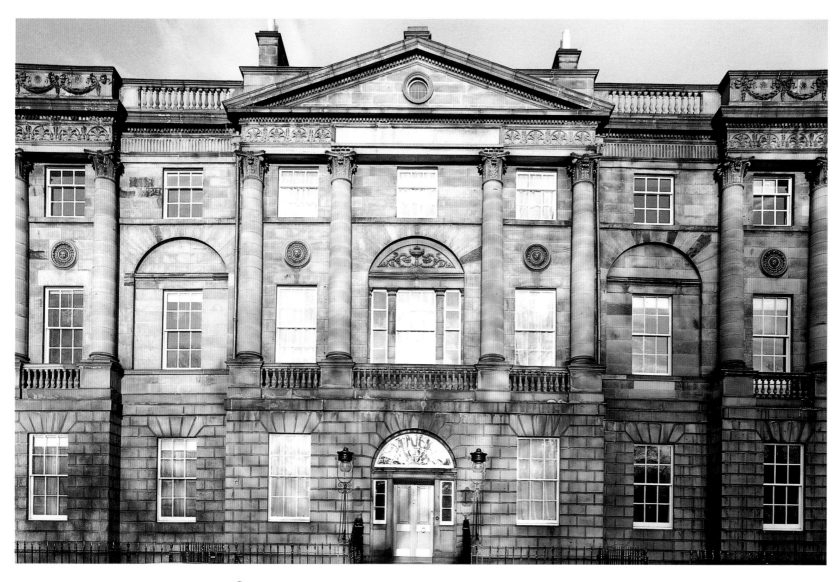

Charlotte Square, Edinburgh – the cool classicism of Robert Adams

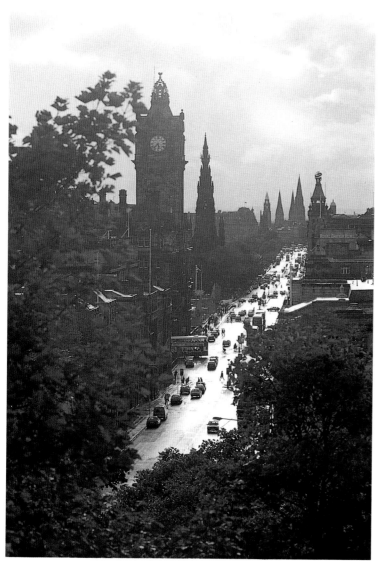

Princes Street, Edinburgh: the 'Athens of the North' or 'Auld Reikie' – two Scottish ways of looking at the capital

St Giles cathedral, the High Kirk of Edinburgh

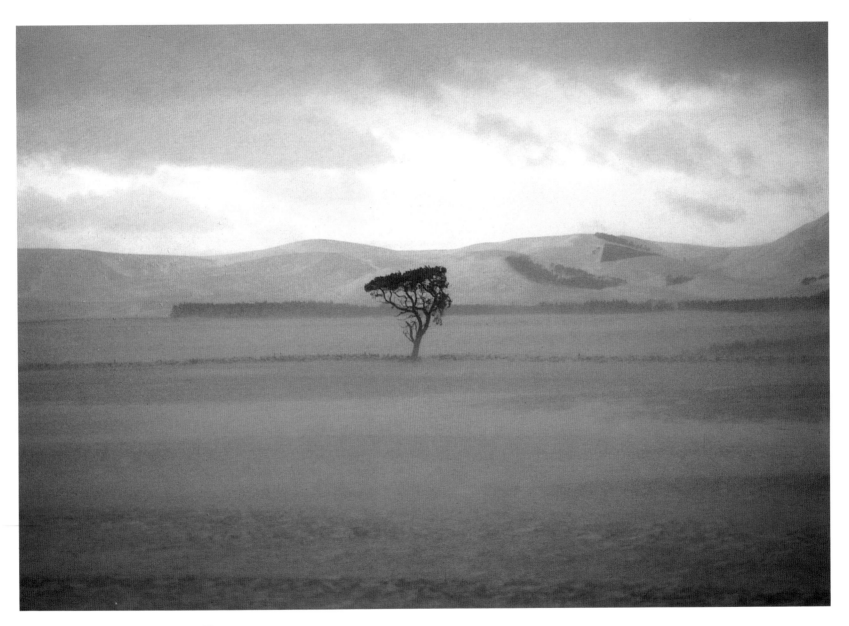

Pentland Hills: 'Oh wert thou in the cauld blast, Oh yonder lea, on yonder lea:'

Robert Burns

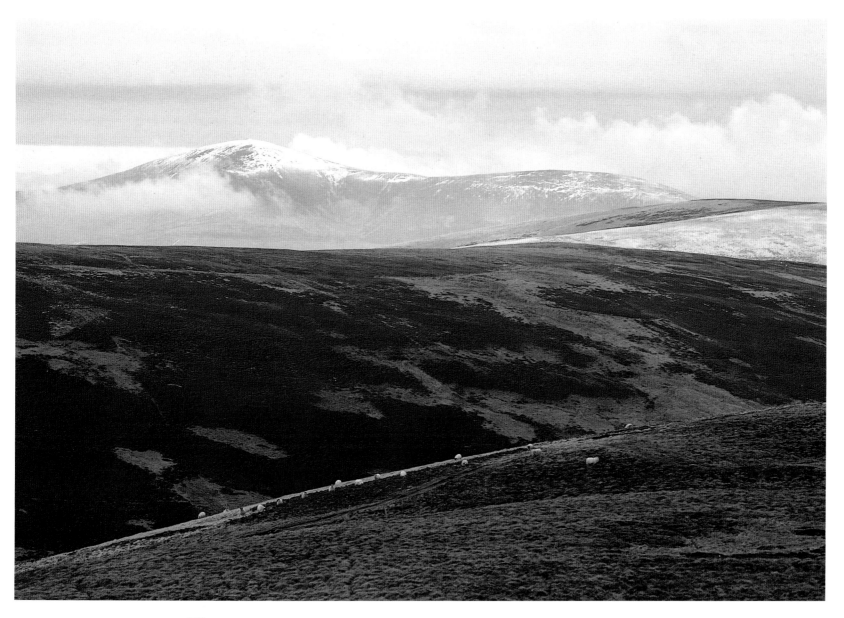

Tinto Hill, the 'Hill of Fire' near Douglas, Lanarkshire. A distinctive landmark used throughout history as a beacon

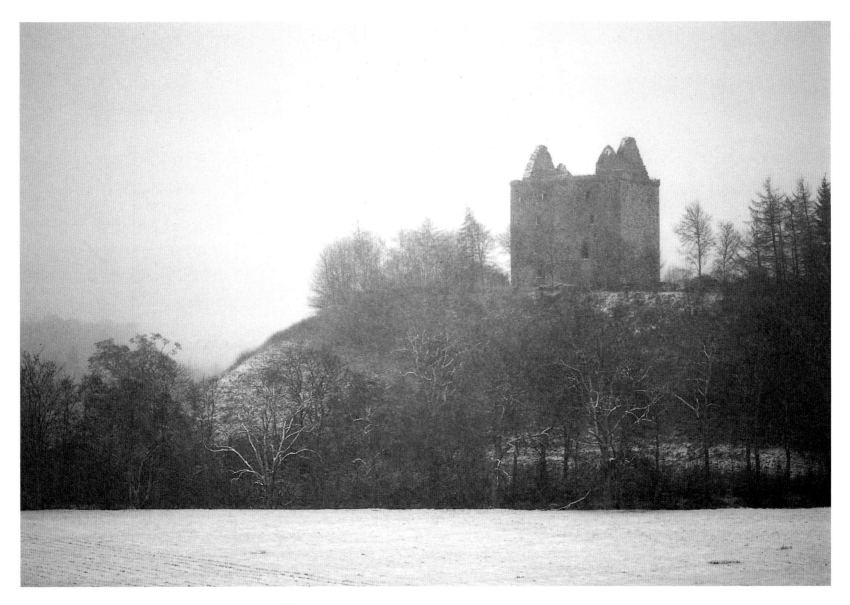

Dark mid-winter at Newark Castle near Selkirk

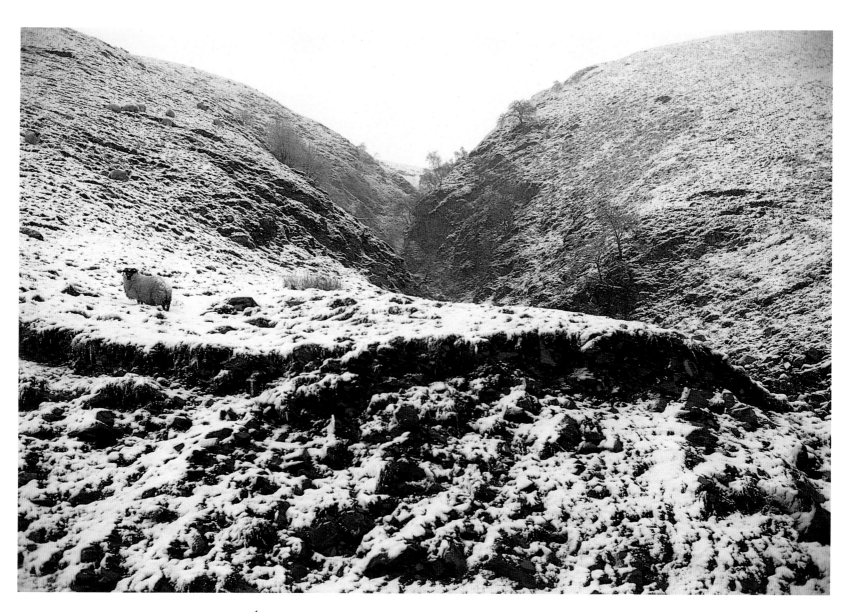

At the still, cold heart of the Tweedsmuir Hills north of Moffat

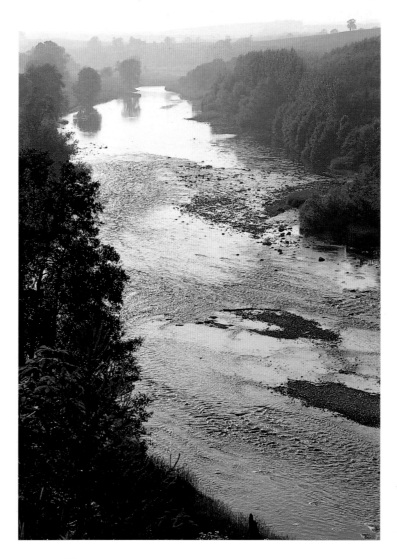

Borderlands. The River Teviot near its meeting with the River Tweed at Kelso

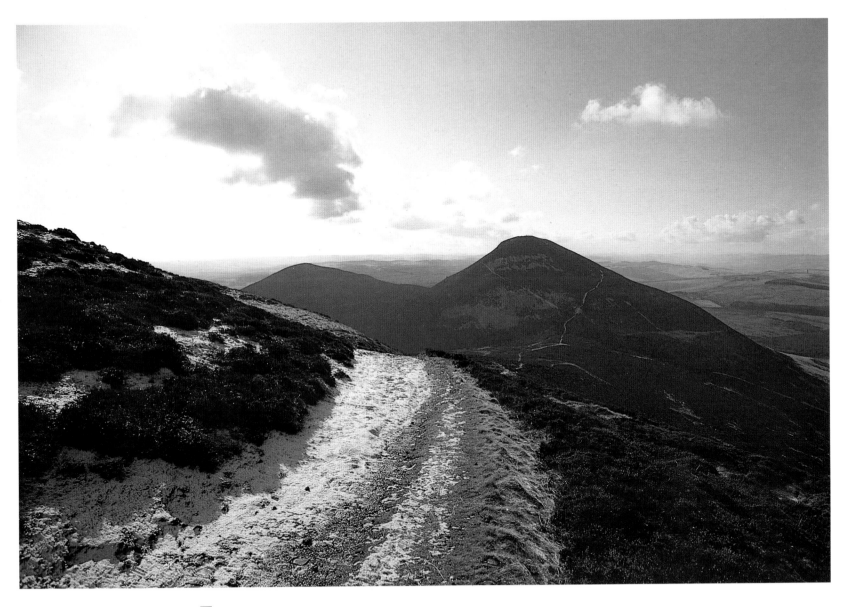

Eildon Hills near Melrose. From the graceful summits may be seen forty places, 'famous in war and verse' according to Sir Walter Scott

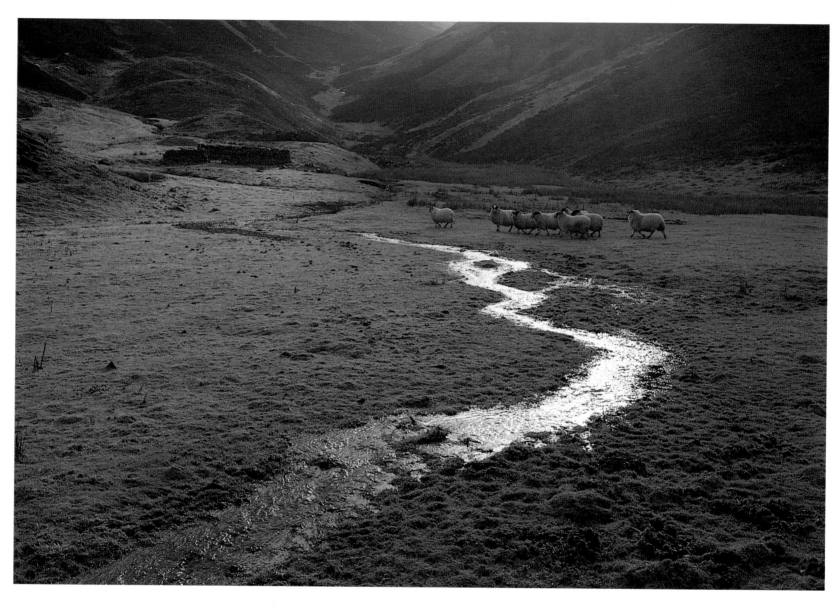

A snail's trace of water below Culter Fell, near Biggar

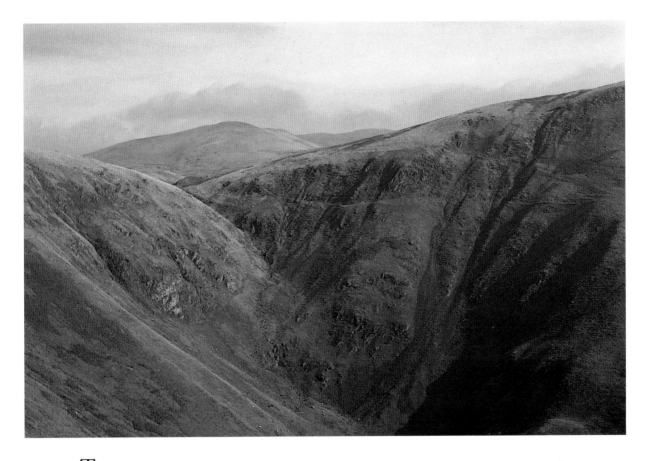

The Devil's Beef Tub, Moffat, was used by Border reivers as a pound for stolen cattle.
'A deep, black, blackguard-looking abyss…'

SIR WALTER SCOTT

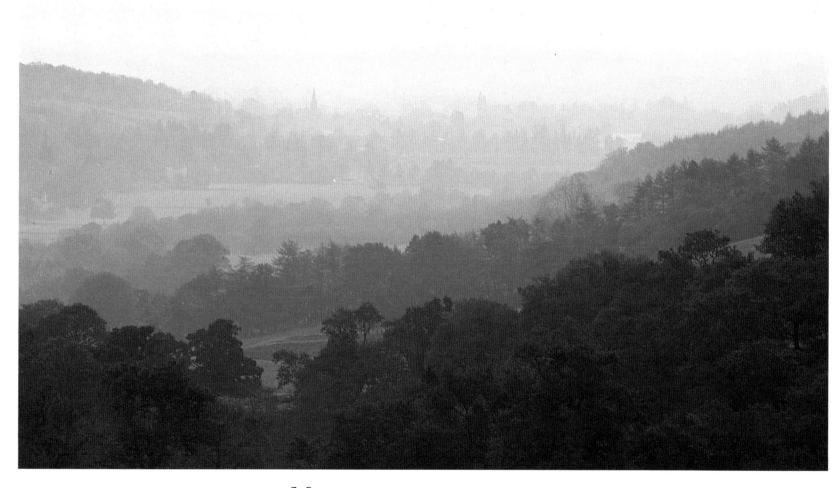

Misty Annandale, with Moffat in the distance

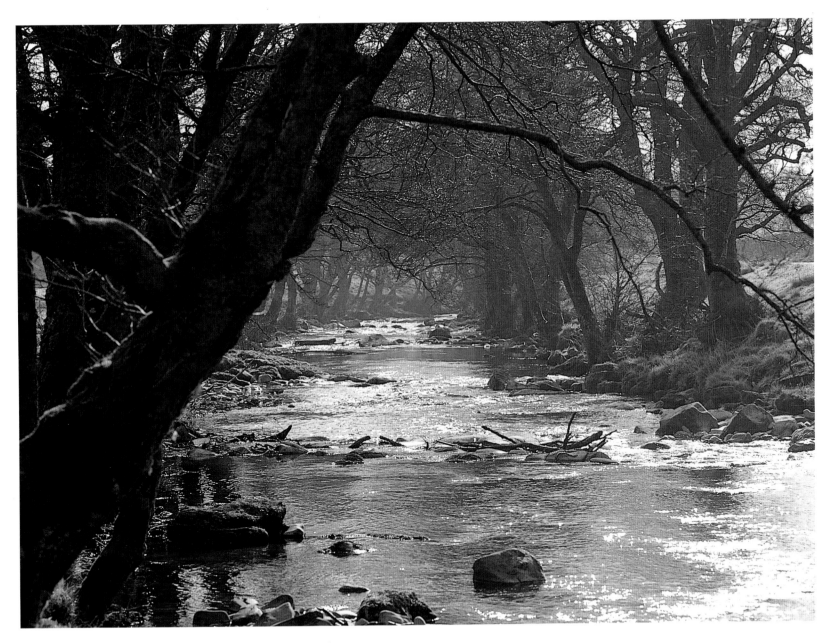

The quiet glide of Hermitage Water

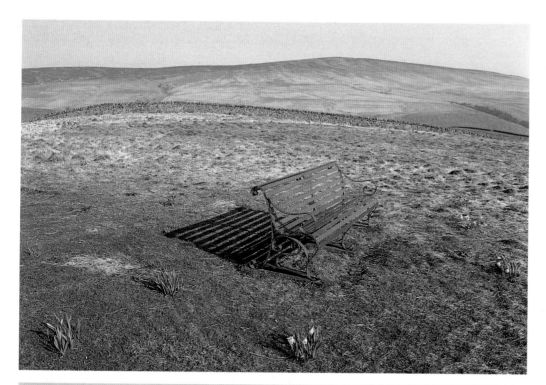

Bench on Black Edge Moor, Liddesdale

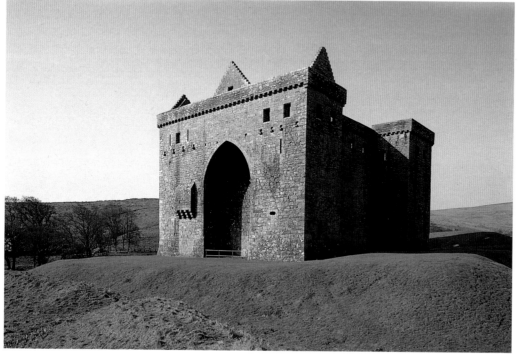

Hermitage Castle, a gaunt thirteenth-century fortress at the heart of Liddesdale

Ettrick Forest – mid-winter grazing, on land like the sea

TECHNICAL NOTES

In landscape photography it is not necessarily the type of equipment which is crucial, more often than not success depends on feeling happy with what you use. Some purists proclaim that serious landscape photography can only be achieved using large-format cameras. This is pretentious nonsense – great paintings were not always executed by the finest tools. It does not really matter what equipment you use as long as the end results are to your liking.

I have always preferred using 35mm cameras as I enjoy the feel of them in my hand and find them easy to use. I use Nikon cameras and a number of lenses ranging from 24mm to 200mm and because of the weight factor I also carry a Nikon 2x converter. I carry some colour correction filters and a hand-held light meter, which I double check with the camera's TTL meter.

I would recommend some basic practical tips. A tripod gives you greater scope to shoot in more difficult light conditions; but do not lumber yourself with a heavy one as good landscape photography often entails walking many miles over difficult terrain. For the same reason I also recommend a good camera bag, preferably a rucksack type which distributes the weight evenly over both shoulders. The bag I use carries an ample amount of equipment, is waterproof and is easily accessible.

It is important to find a make and type of film that suits your needs; so it is worth experimenting in a variety of weather conditions and at different times of the day. I use Kodachrome 64, Kodachrome 200 and Ektachrome 800/1600, depending on the type of conditions in which I am shooting and the effect I am trying to achieve.

Finally, remember to keep your equipment clean, especially the lenses – I have seen many expensive lenses looking like the bottom of beer bottles!

SIMON MCBRIDE

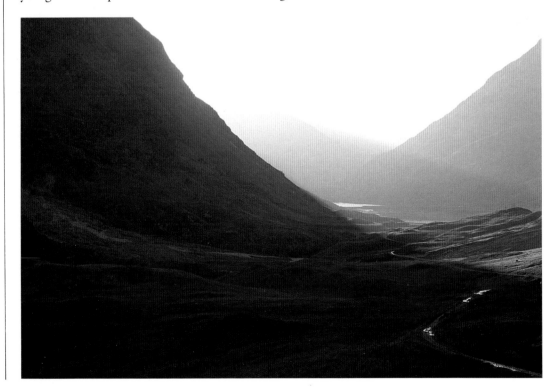

Glen Coe:

'The peat burns brimming from their

cups of stone

Glow brown and blood-red down the

vast decline …'

G K CHESTERTON